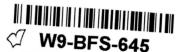

Ed Emberley's Complete FunPrint Drawing Book

Little, Brown and Company

3 Instructions

4-7 For Instance

8-11 Folks

12-13 Hats

14-16 Action

17-18 Animal Action

19-22 Critters

23-24 Birds

25-27 Holidays

28-29 Flowers

30-31 More Thumbs

32-33 This and That

34-35 Garden

36-37 Pond

38-39 Fingerlings

40-41 Animals

42-43 More Animals

44-45 Birds

46-49 Bean Buddies

50-51 Feelings

52-53 Spring Fun

54-55 Summer Fun

56-57 Fall Fun

58-59 Winter Fun

60-61 More Holidays

62-63 Halloween

64-65 Dasher, Dancer, Prancer...

(Christmas)

66-67 Land, Sea, and Air

68-69 Rainbow Clown

70-71 Rainbow Dragon

72 Lion

73 Rainbow Lions

74-75 Sketchbook

76-77 Advanced Finger-Printing

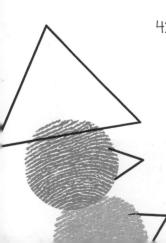

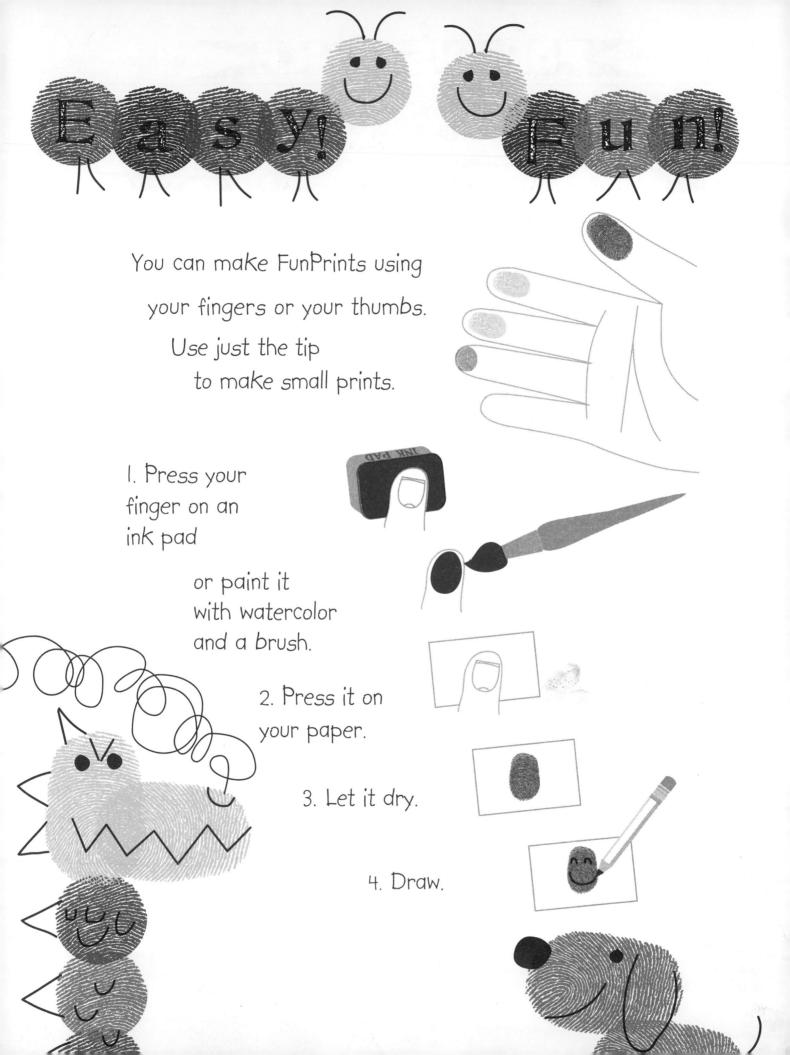

> FOR INSTANCE

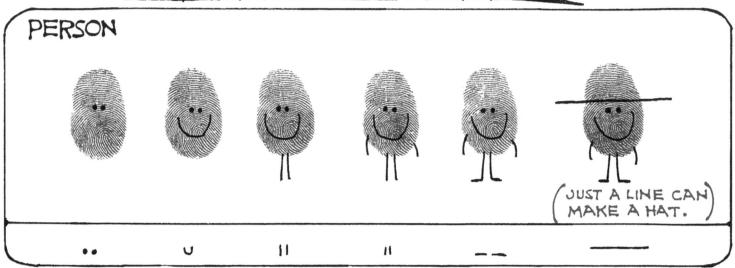

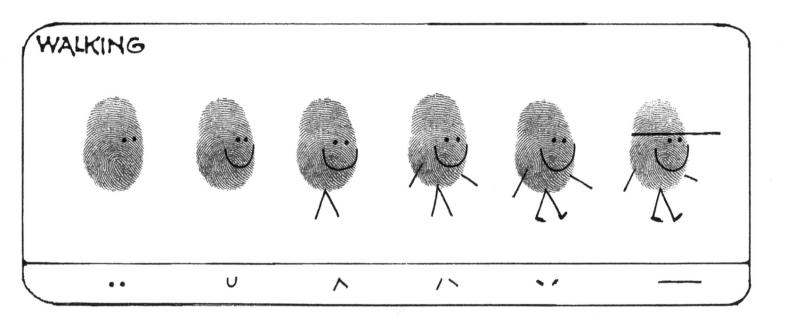

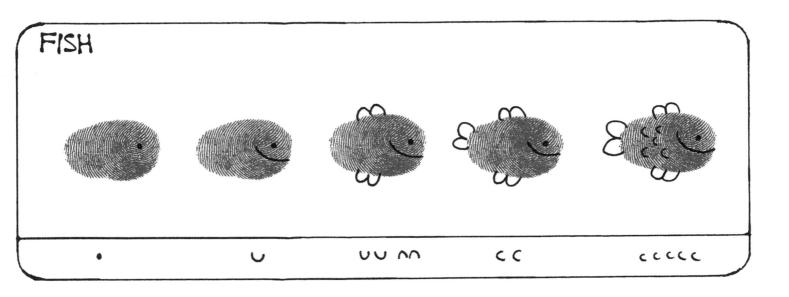

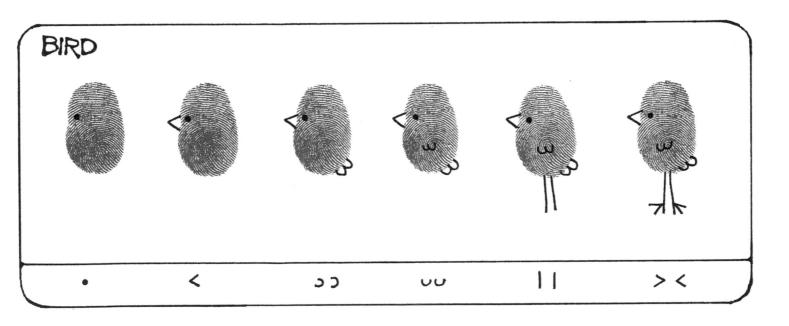

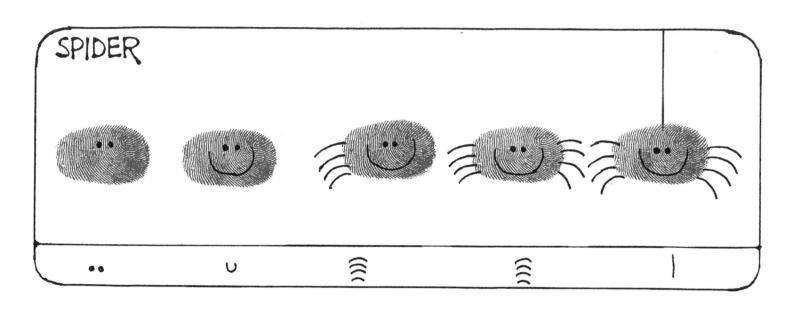

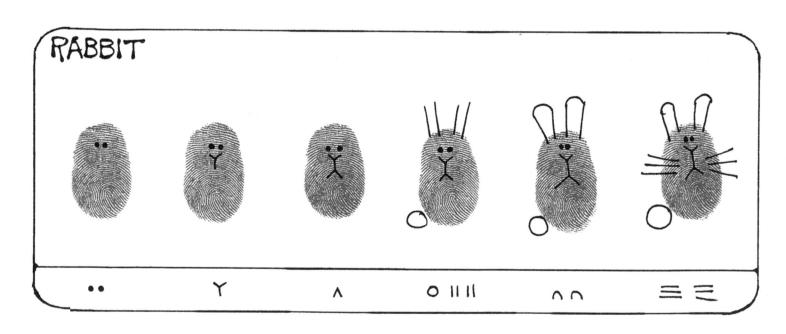

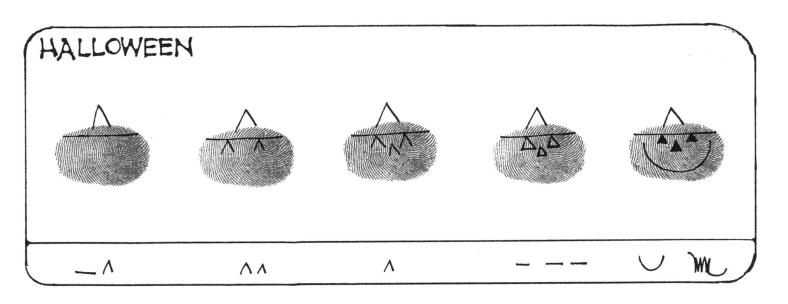

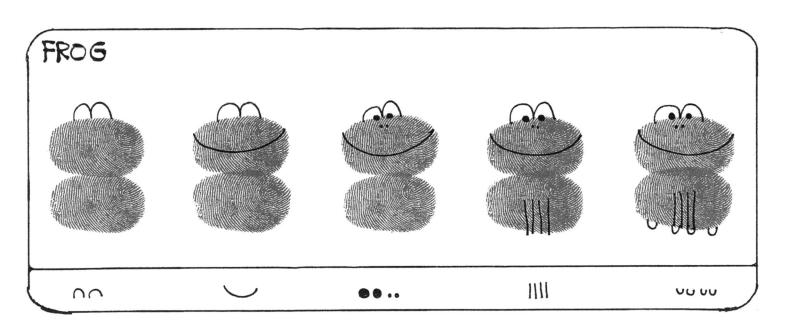

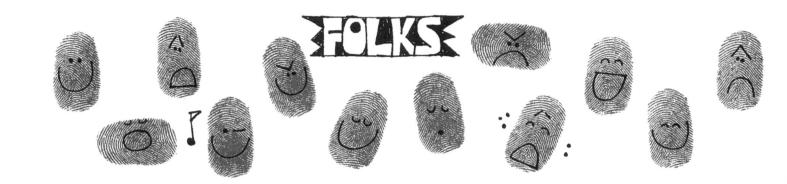

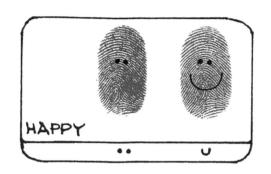

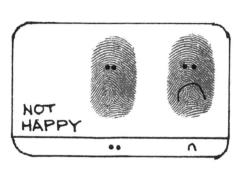

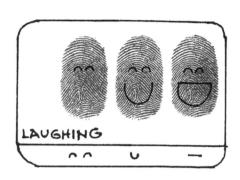

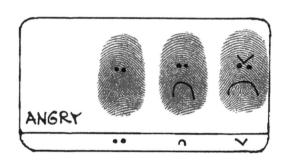

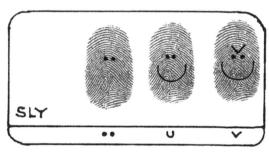

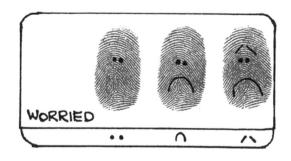

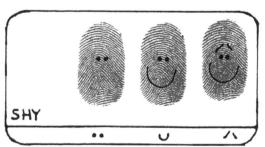

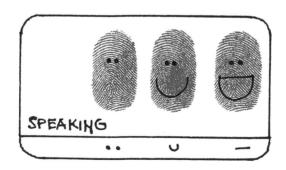

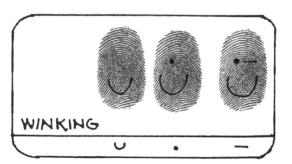

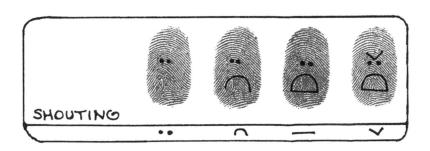

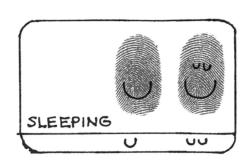

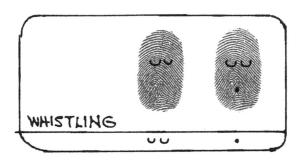

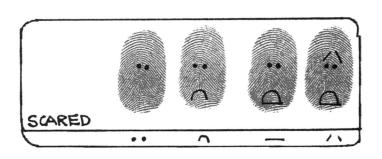

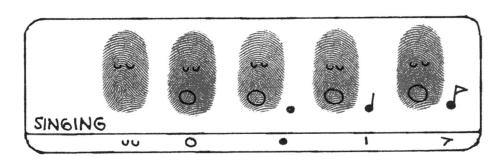

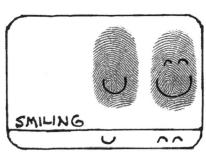

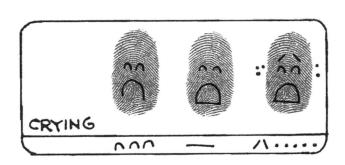

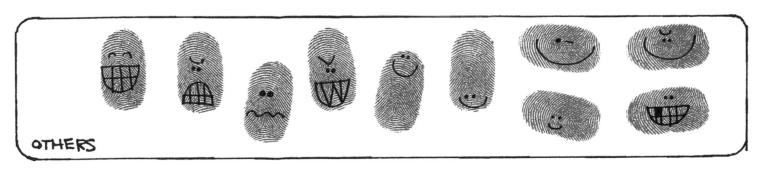

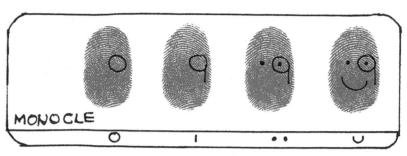

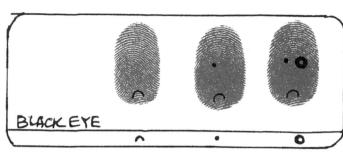

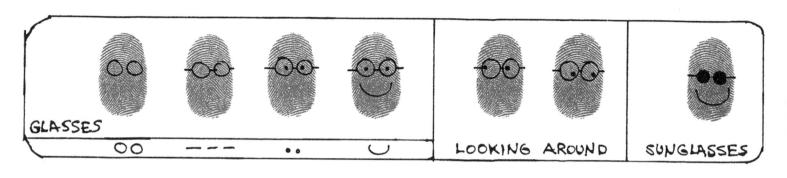

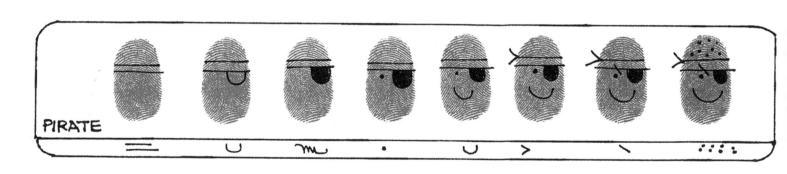

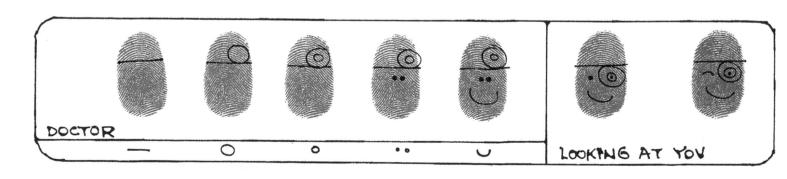

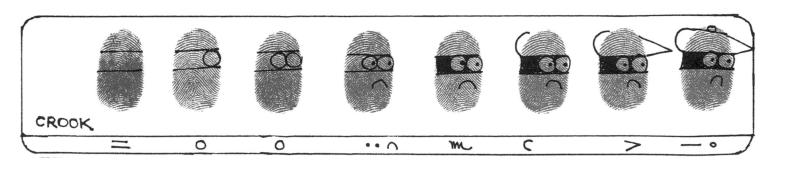

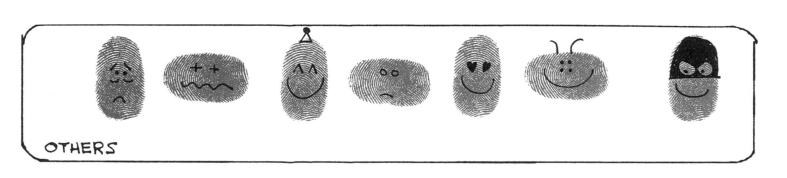

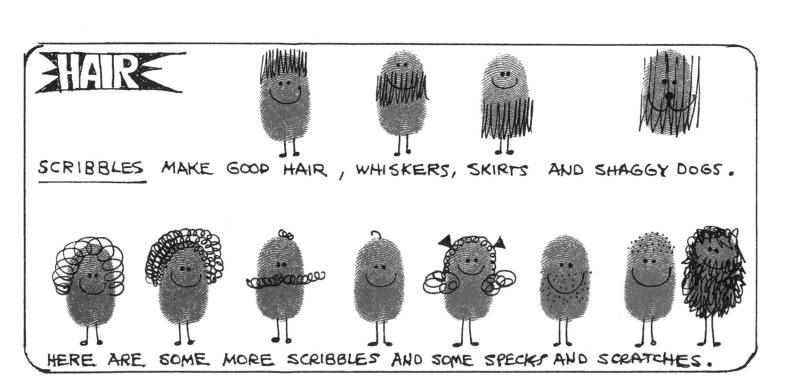

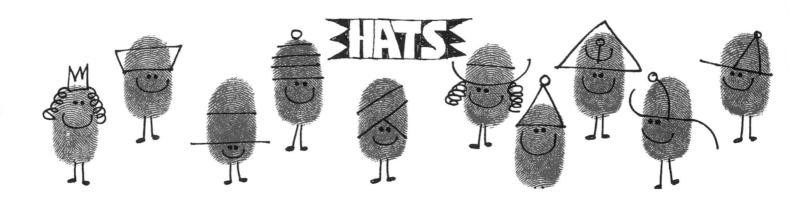

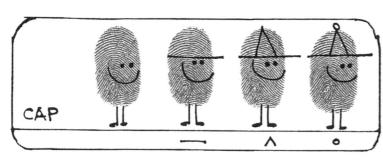

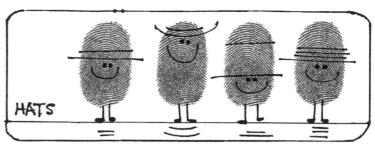

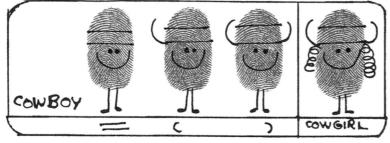

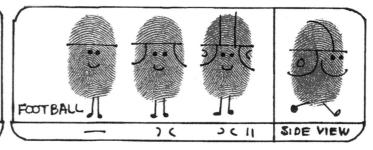

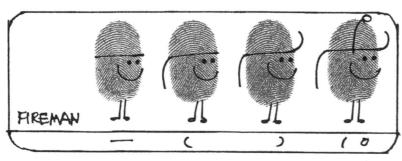

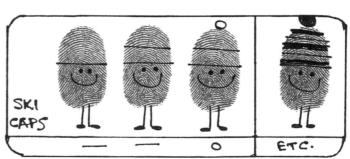

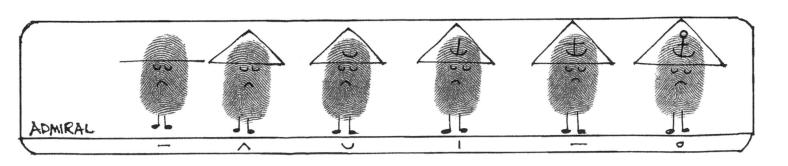

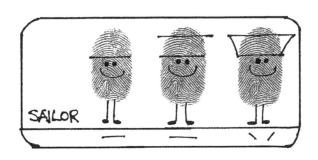

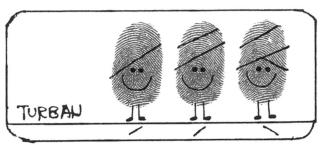

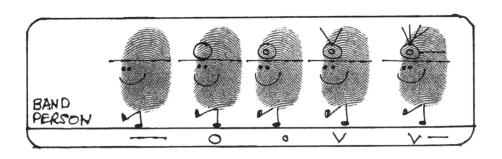

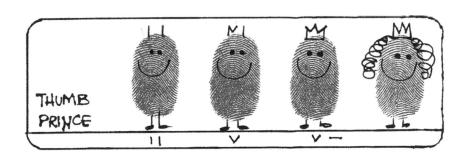

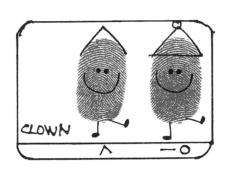

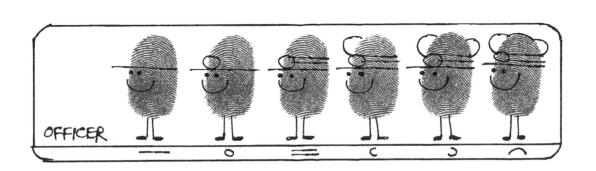

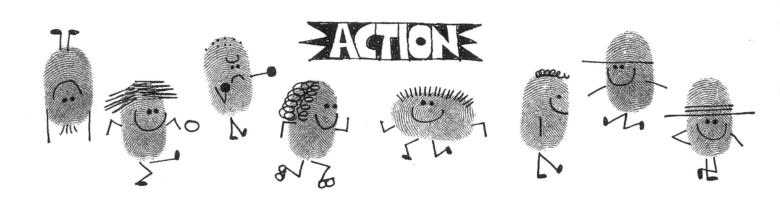

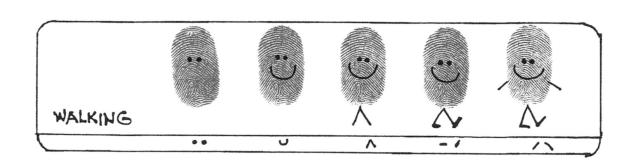

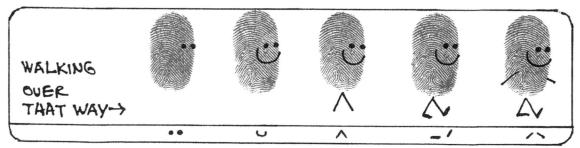

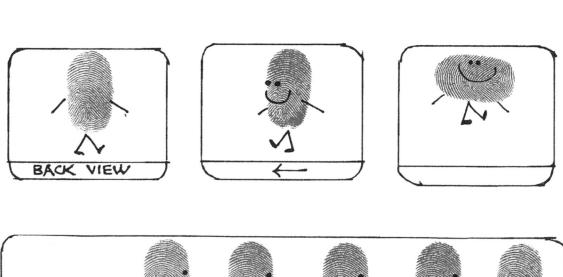

SIDE VIEW

.

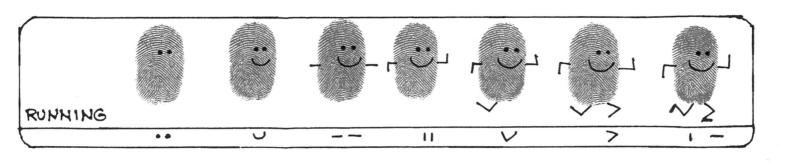

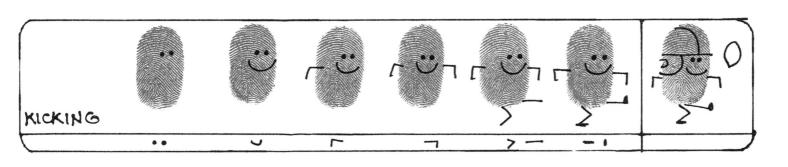

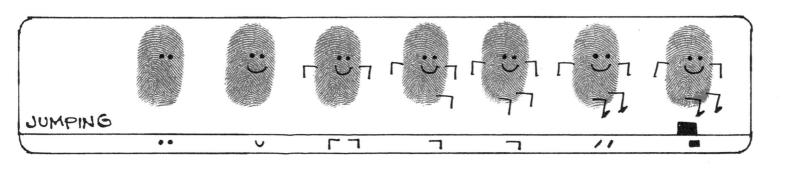

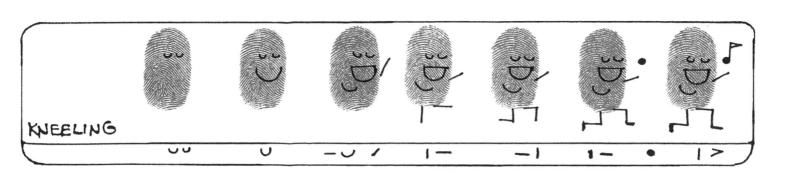

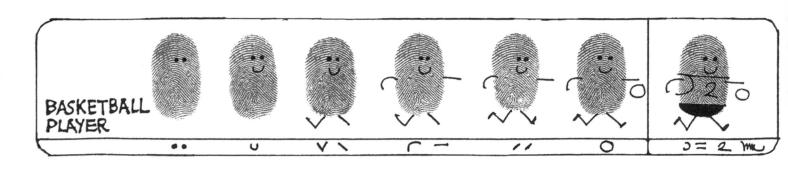

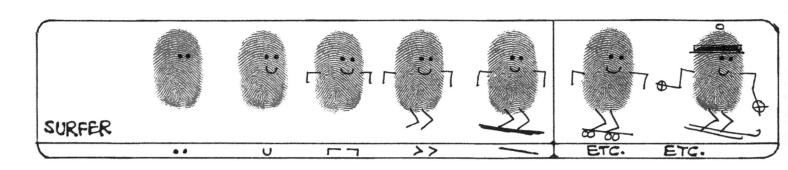

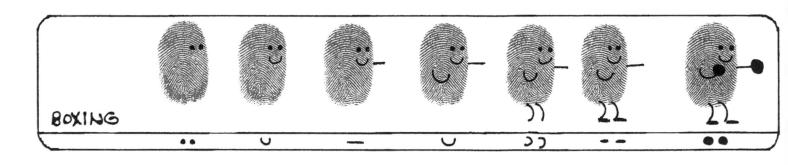

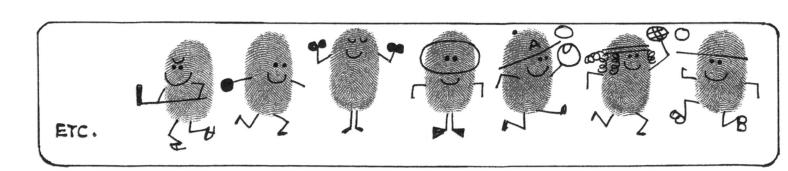

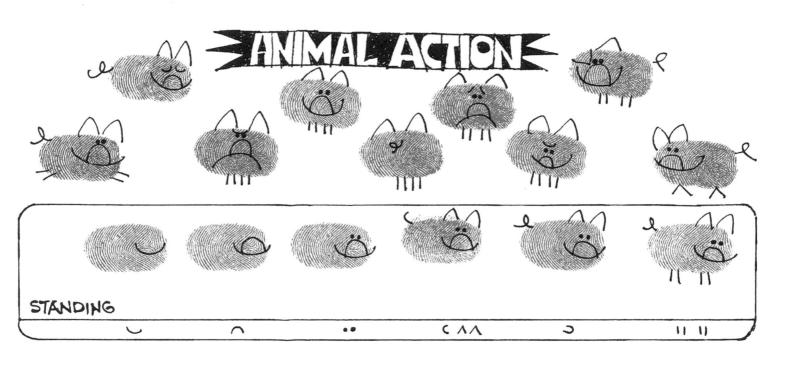

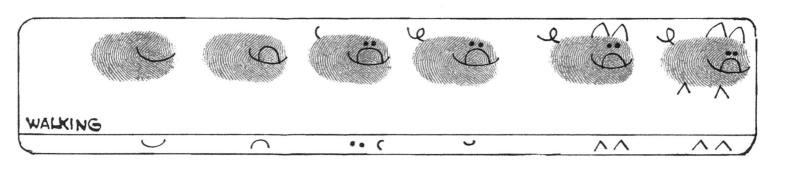

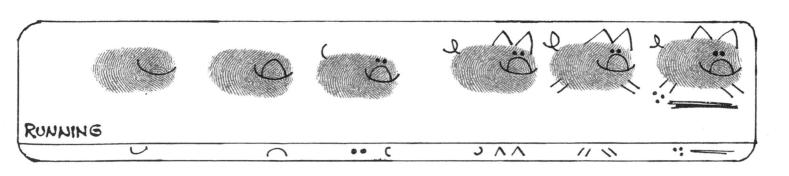

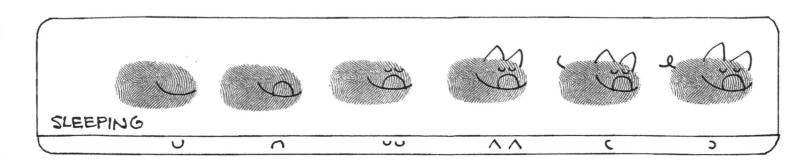

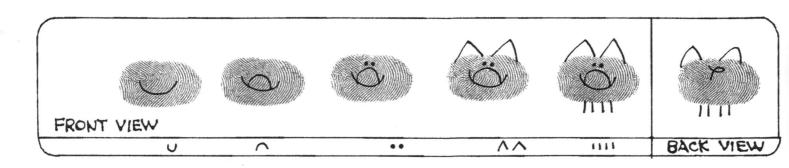

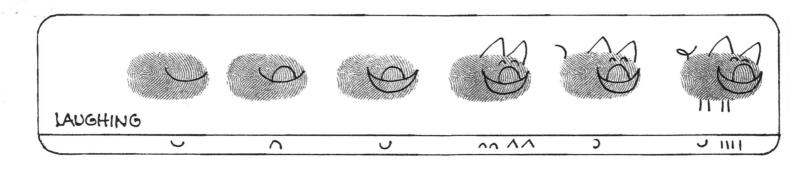

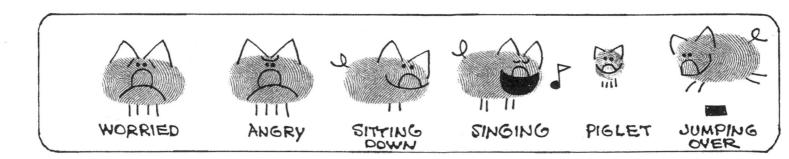

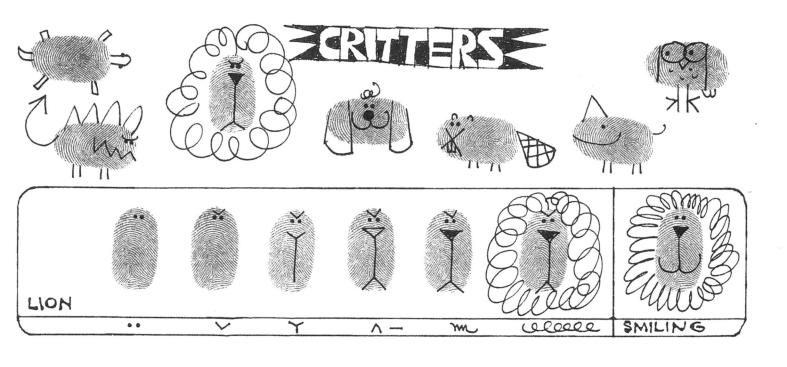

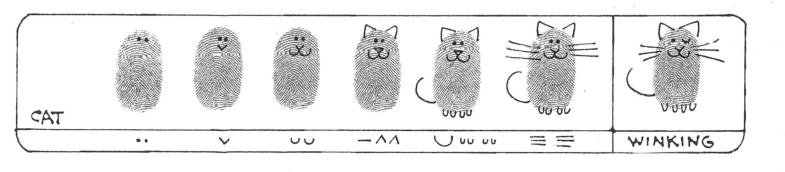

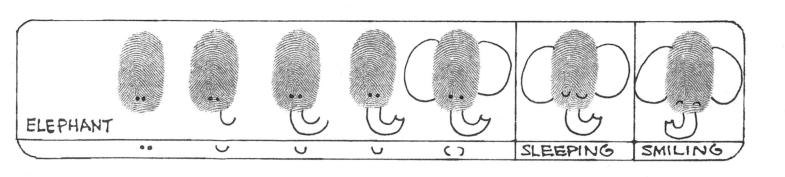

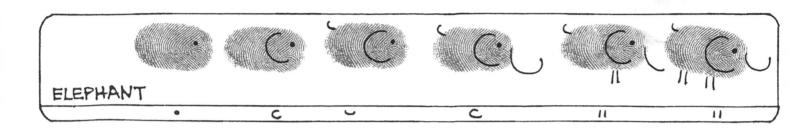

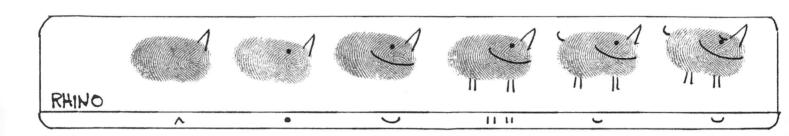

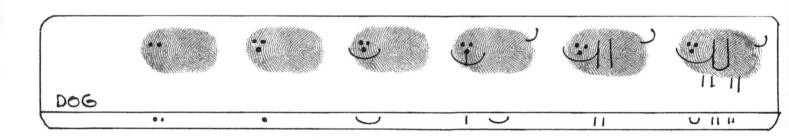

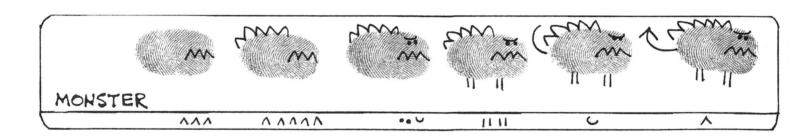

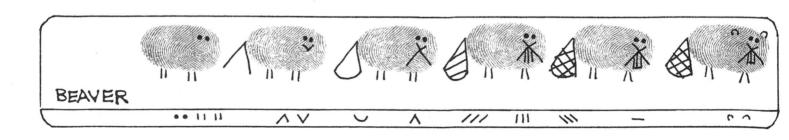

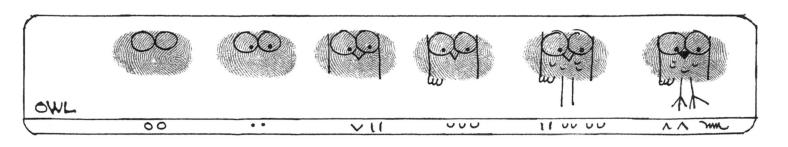

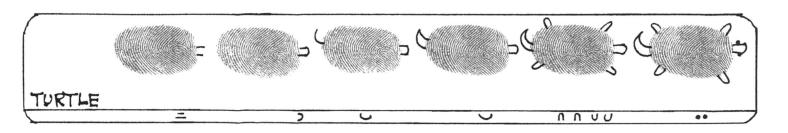

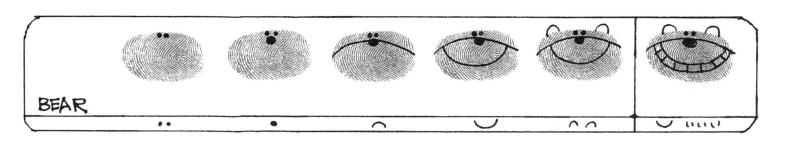

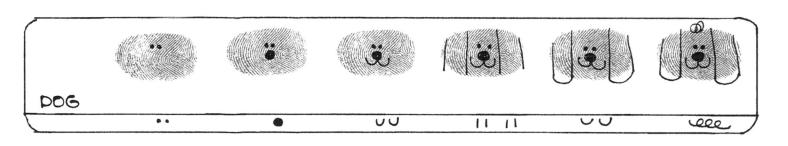

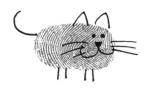

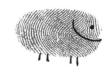

HAMSTER

HAMSTER TOP VIEW

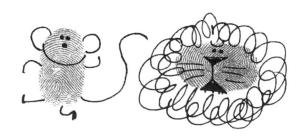

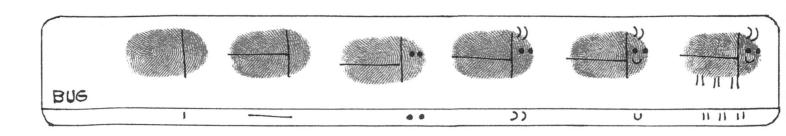

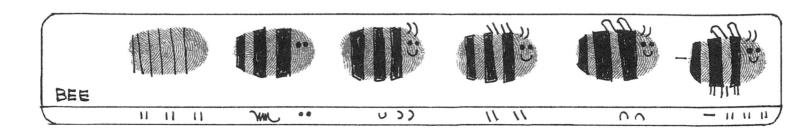

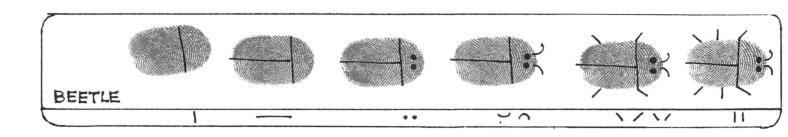

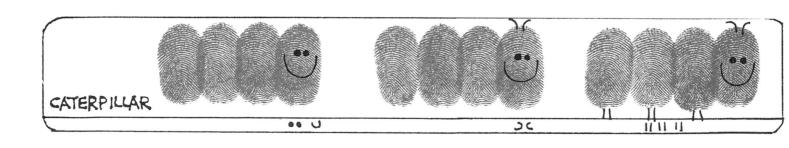

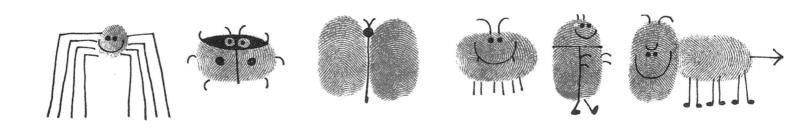

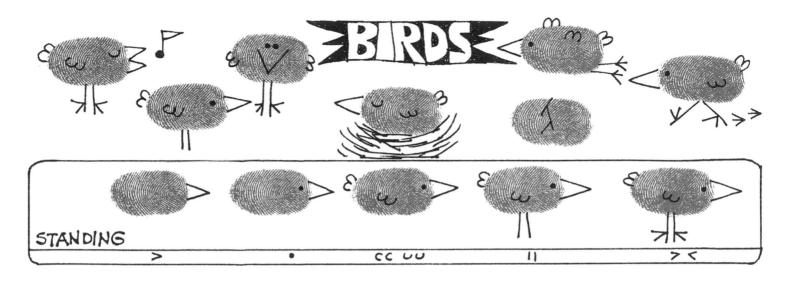

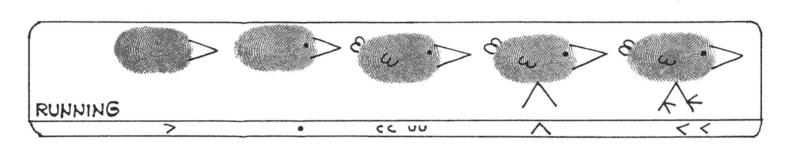

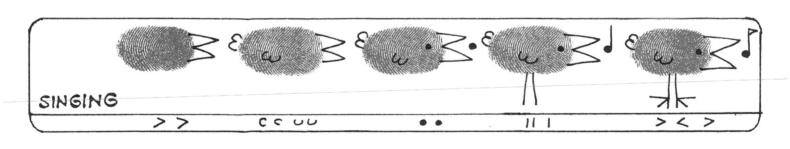

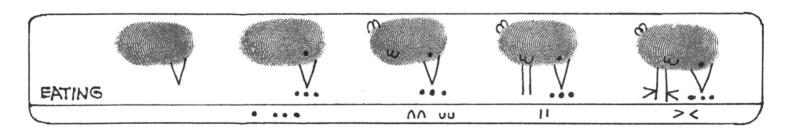

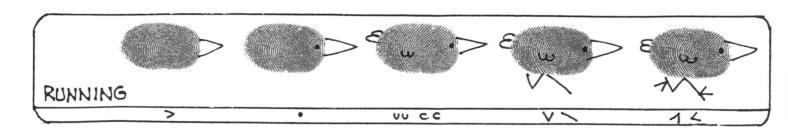

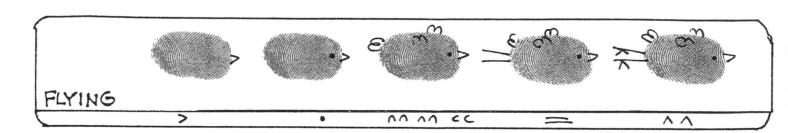

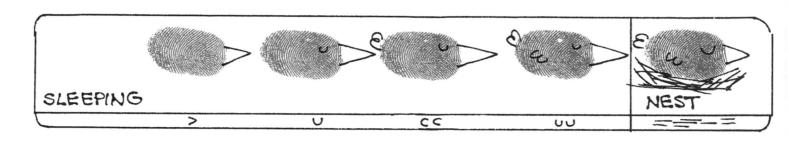

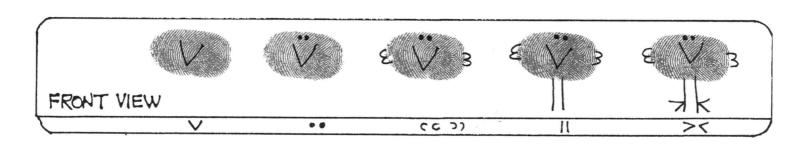

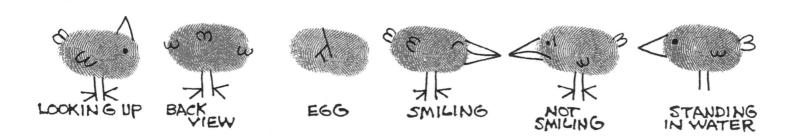

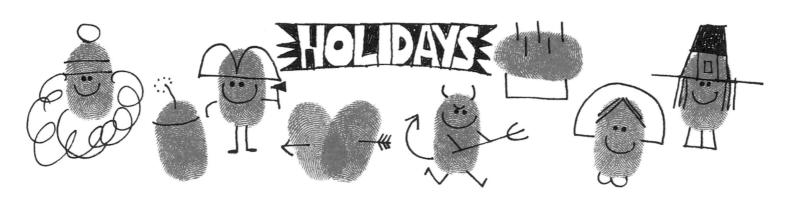

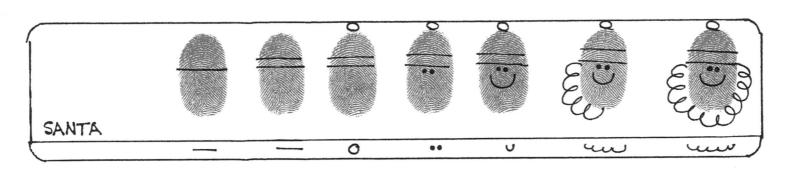

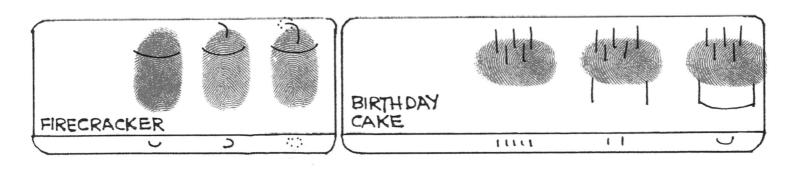

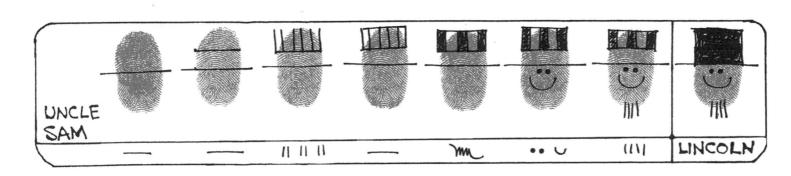

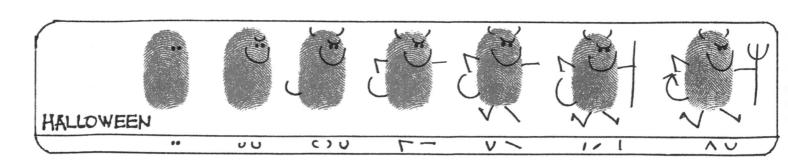

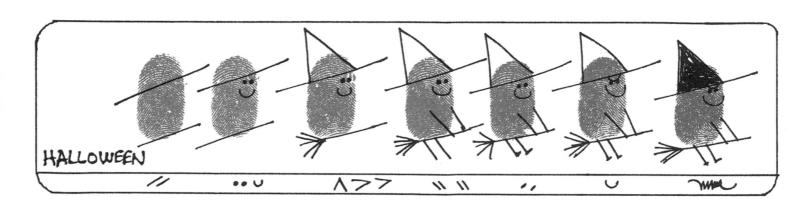

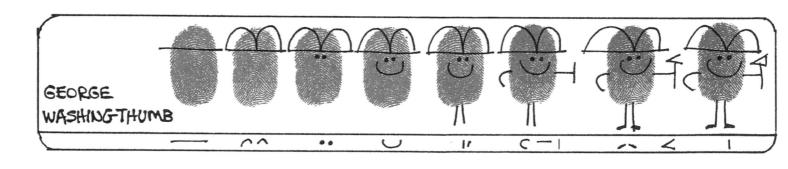

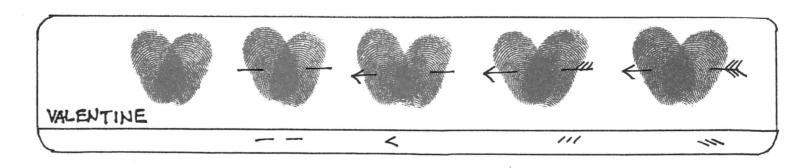

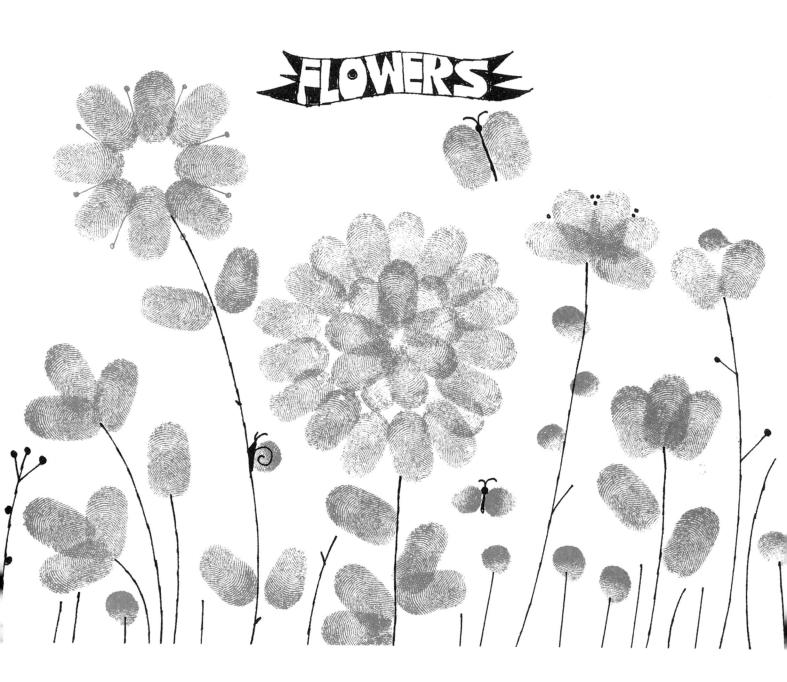

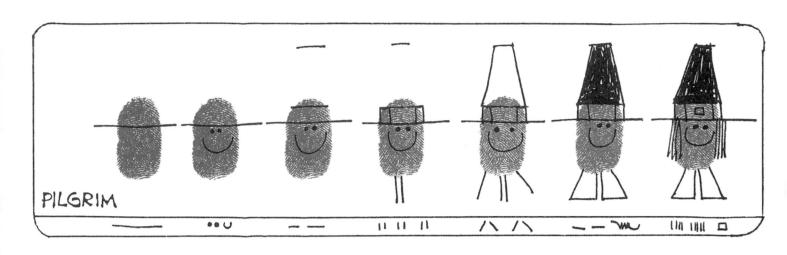

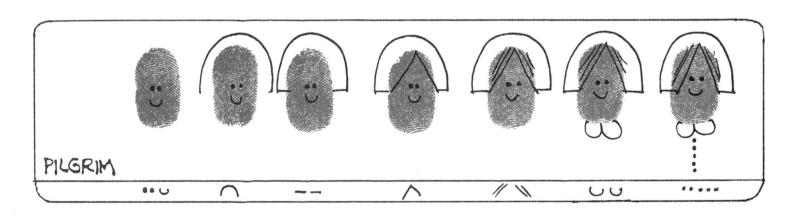

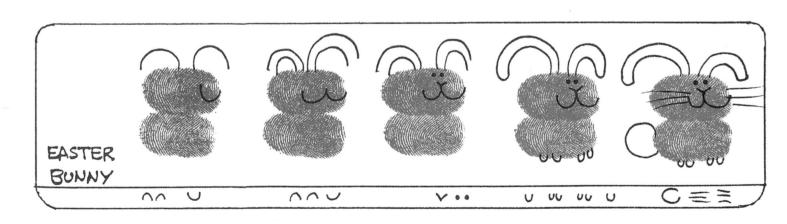

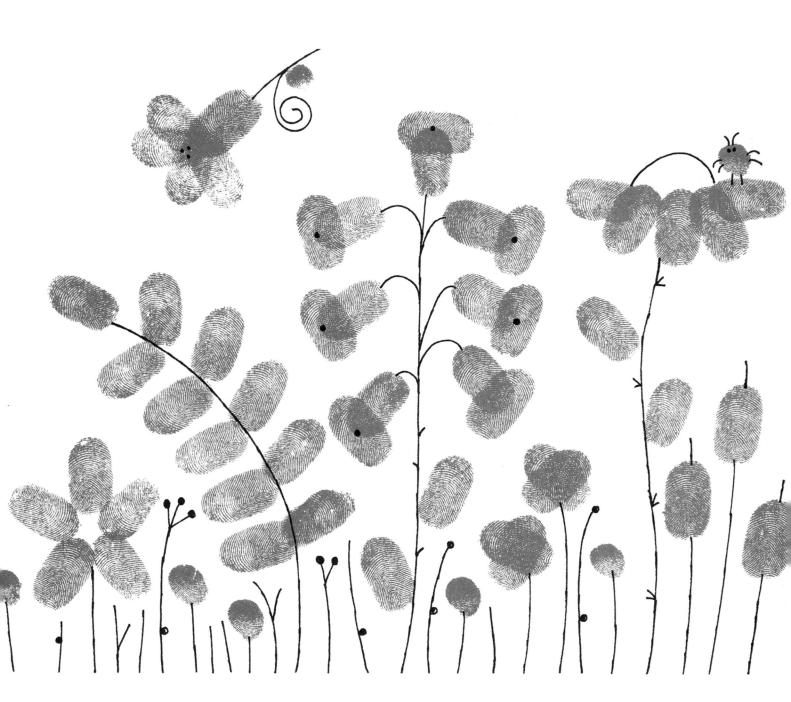

MORE THUMBS

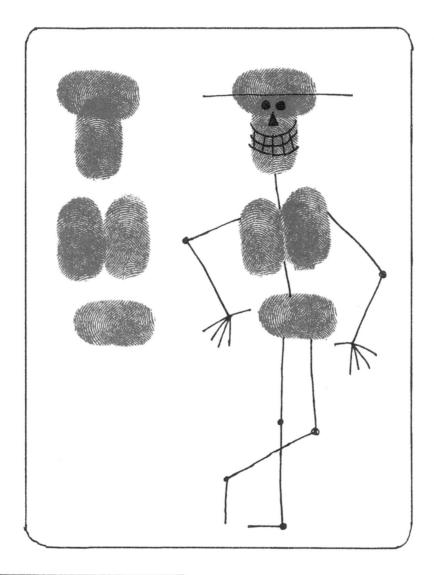

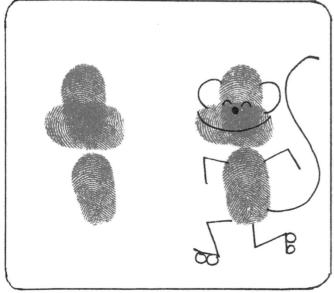

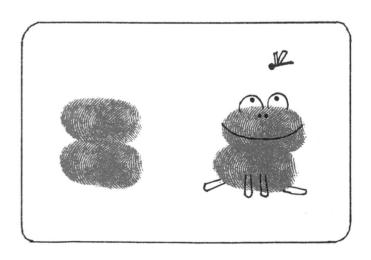

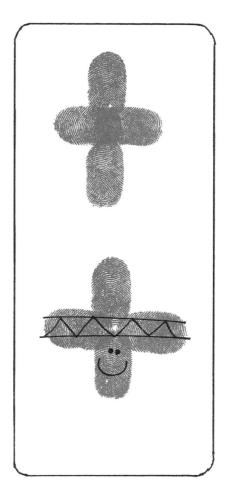

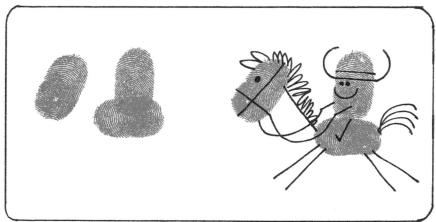

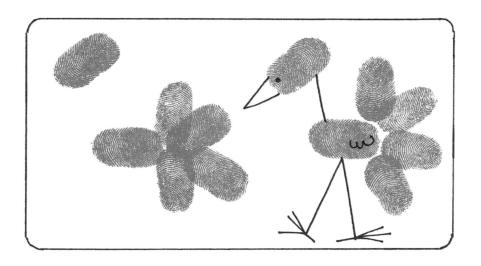

= TH SAND THAT

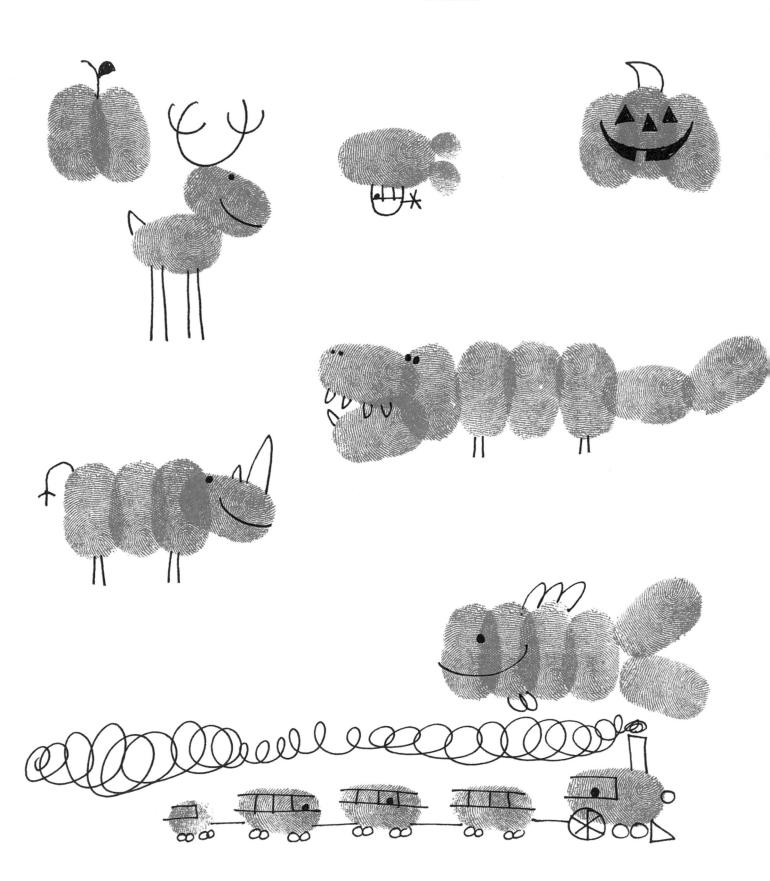

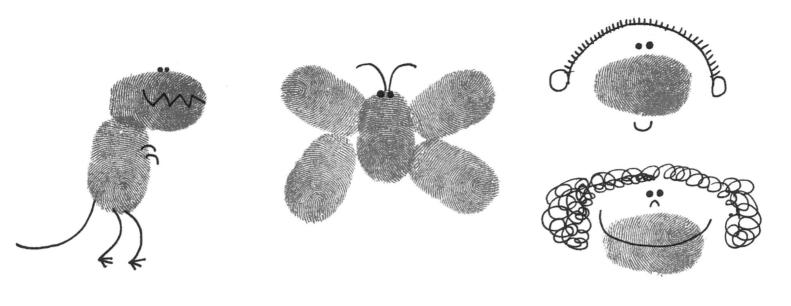

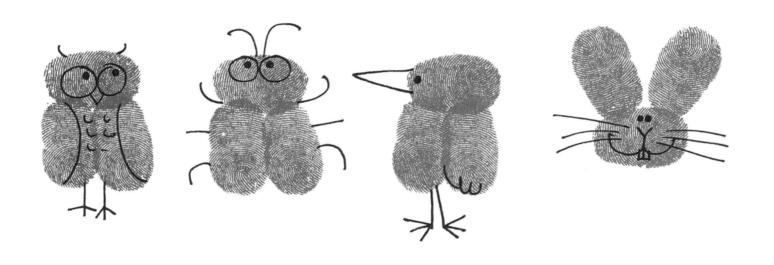

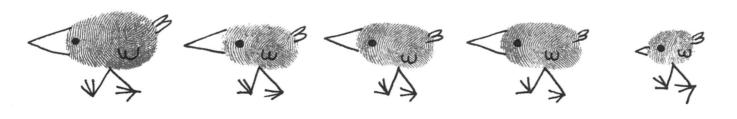

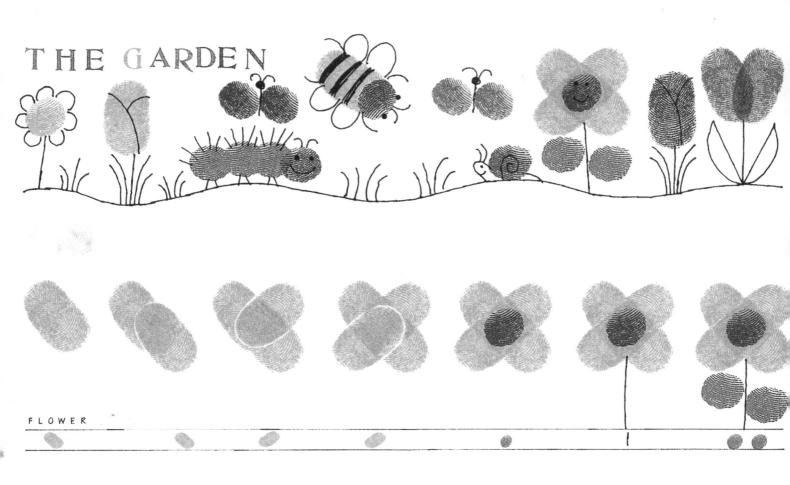

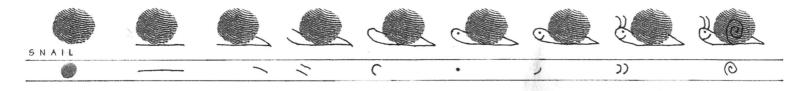

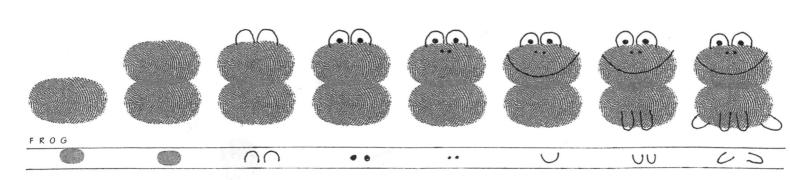

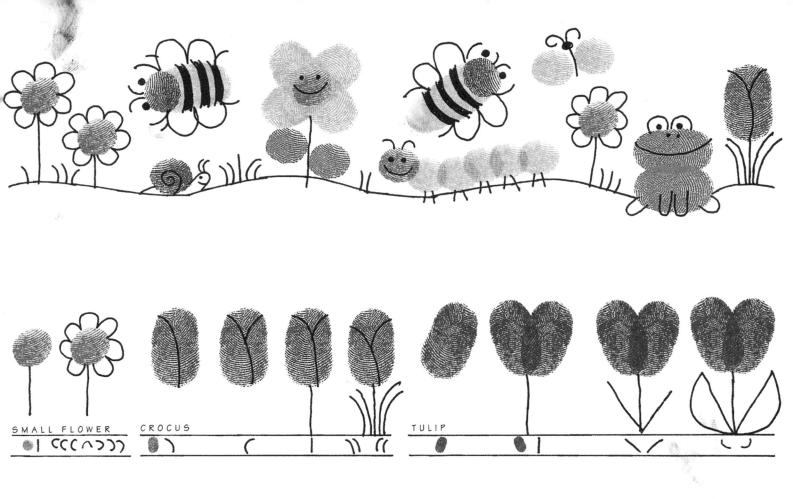

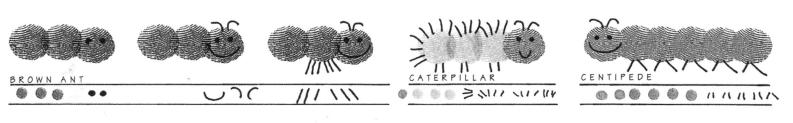

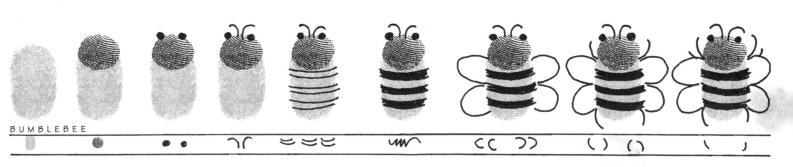

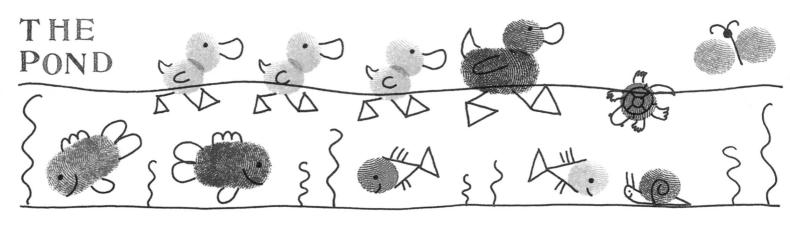

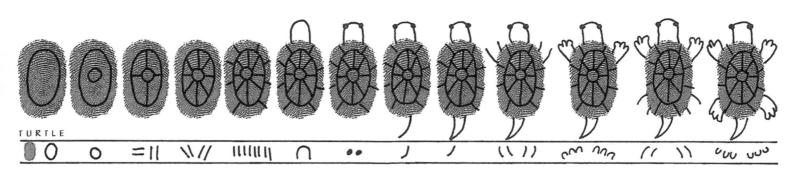

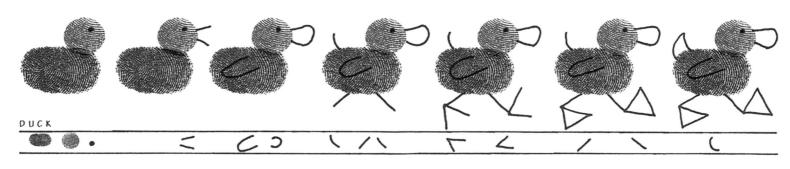

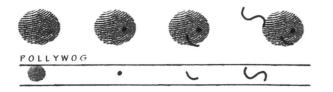

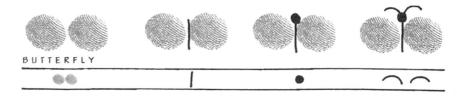

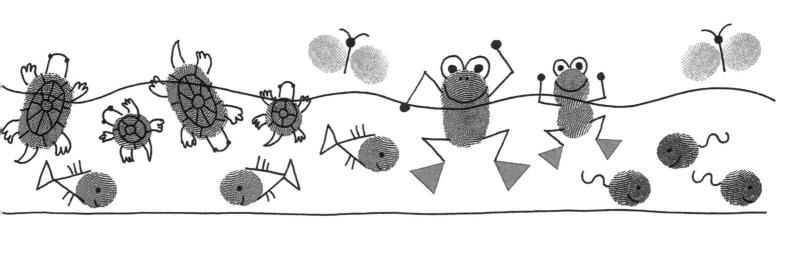

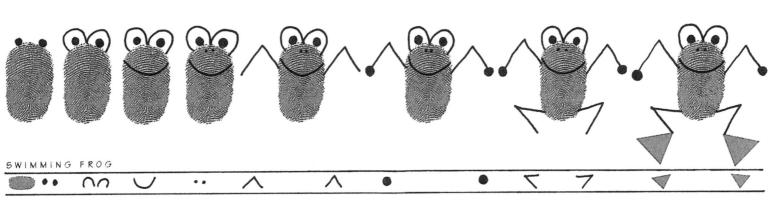

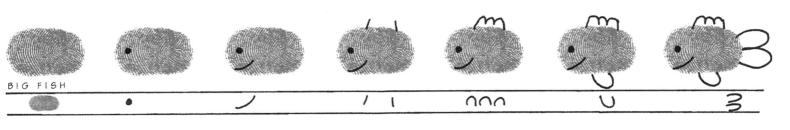

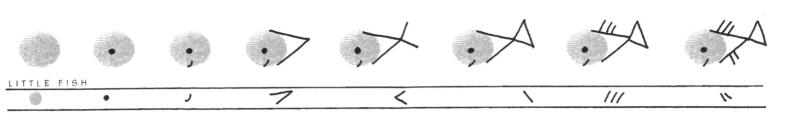

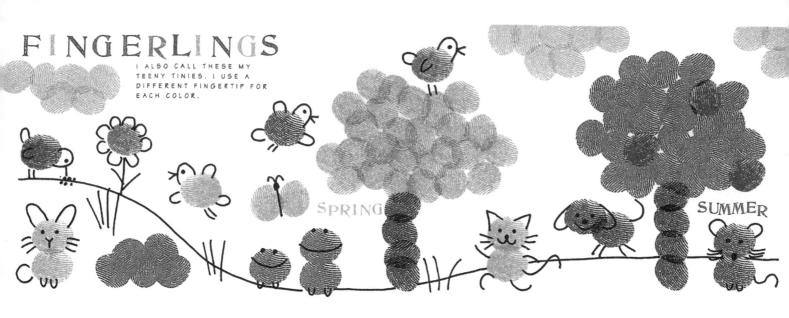

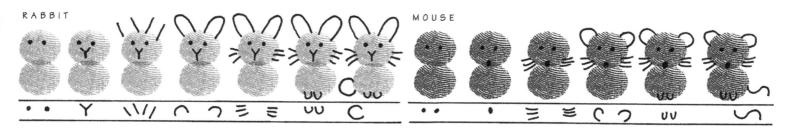

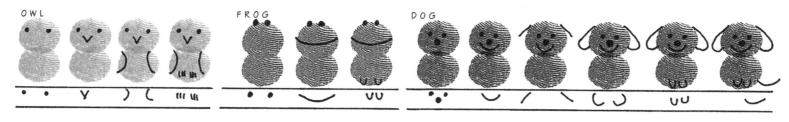

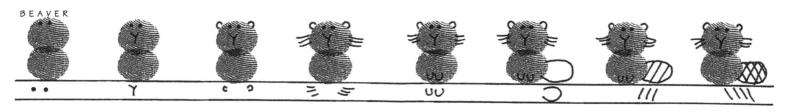

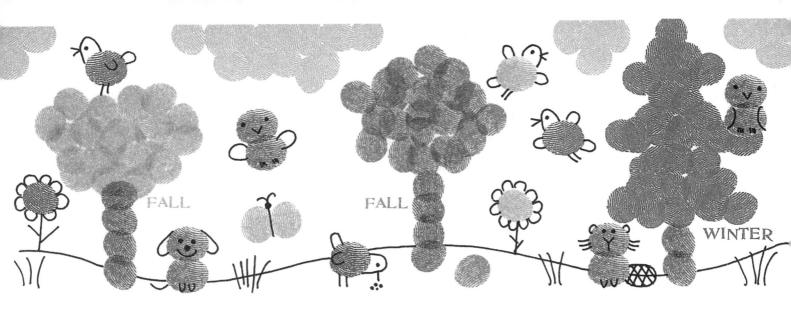

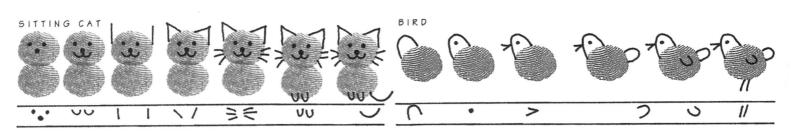

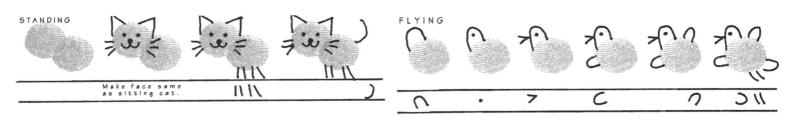

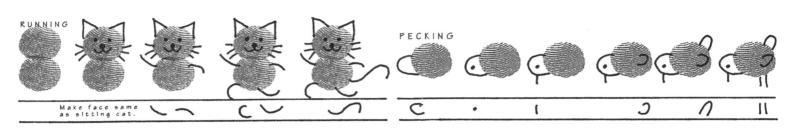

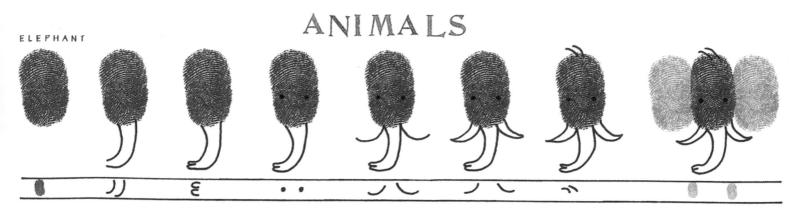

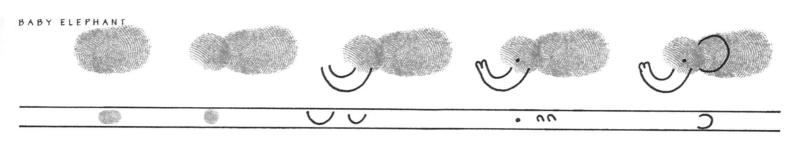

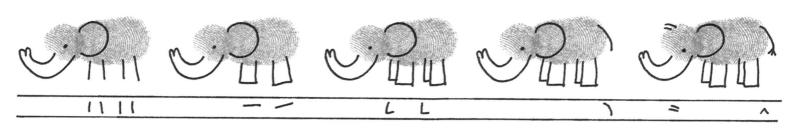

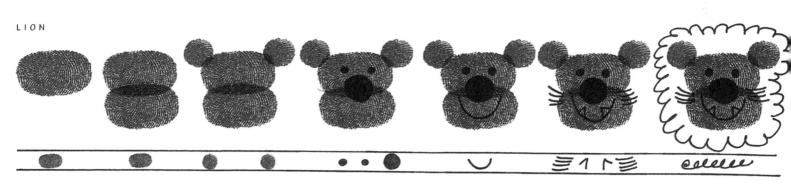

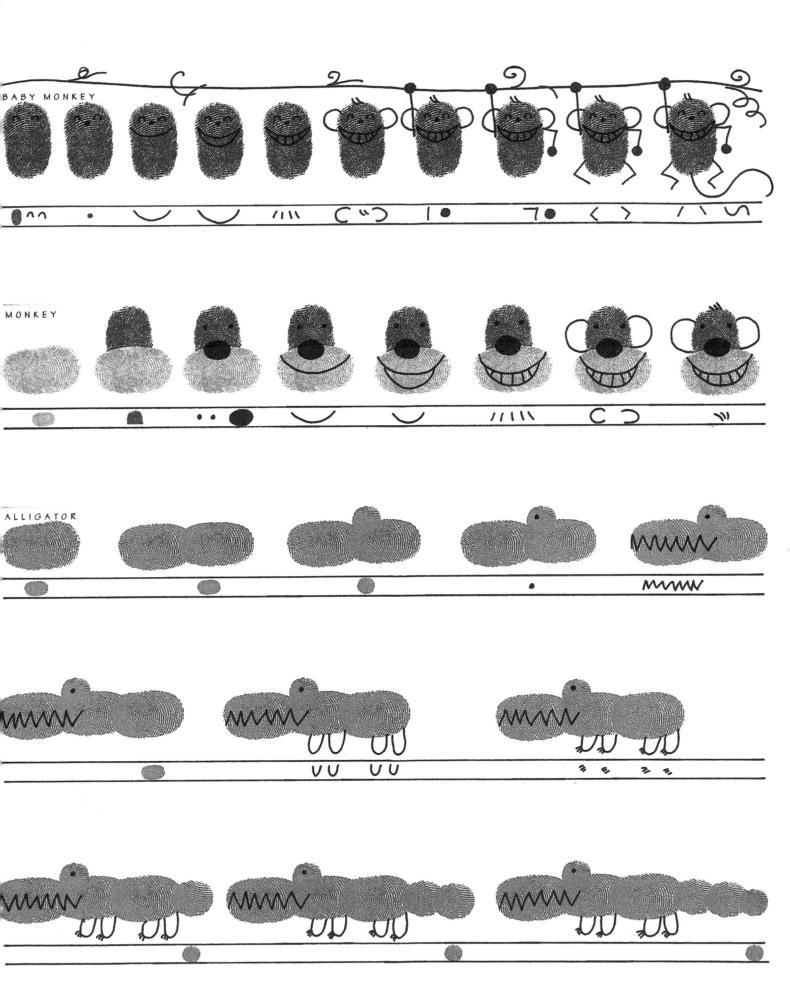

RACCOON

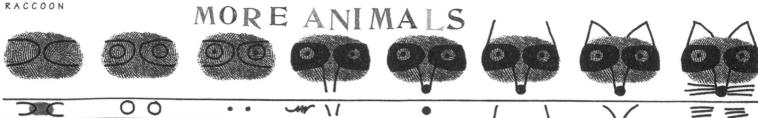

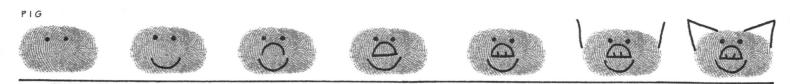

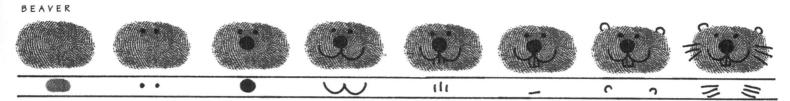

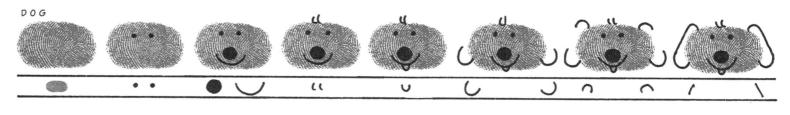

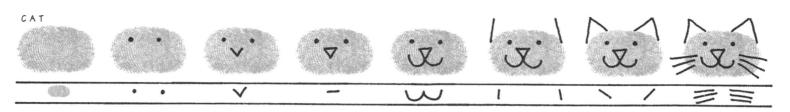

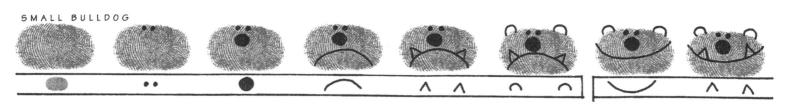

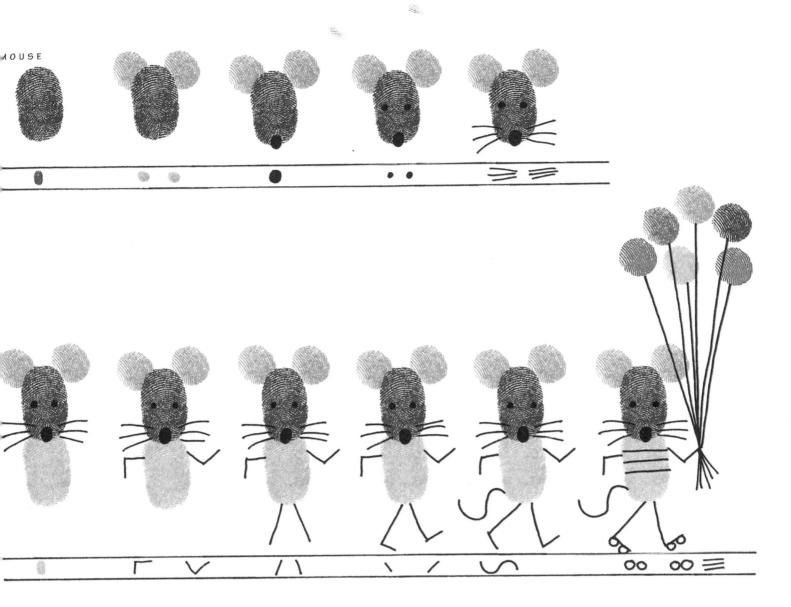

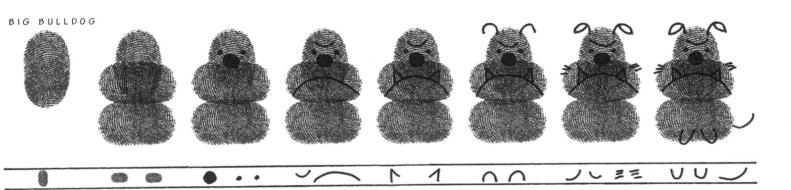

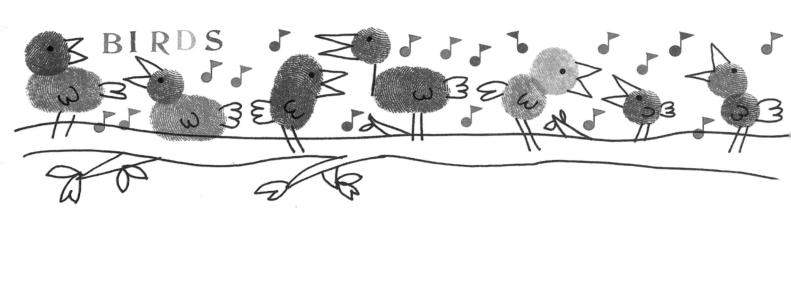

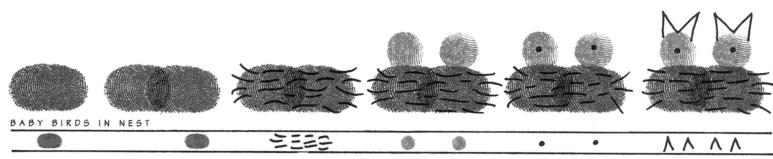

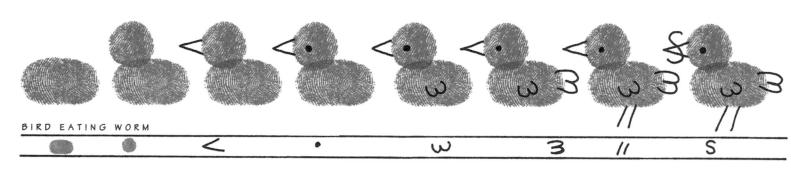

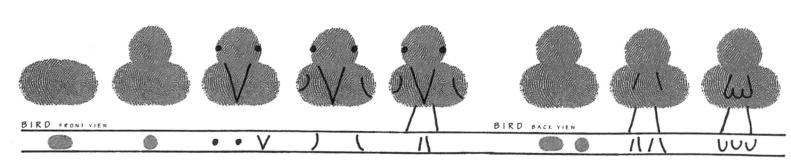

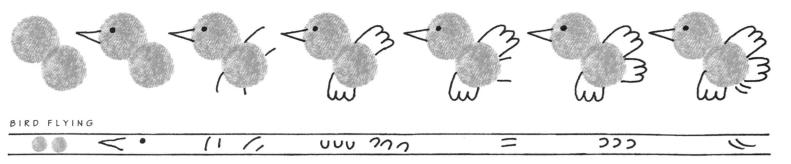

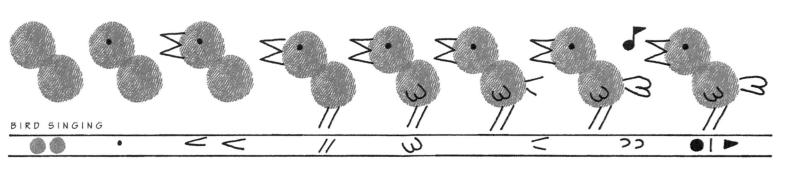

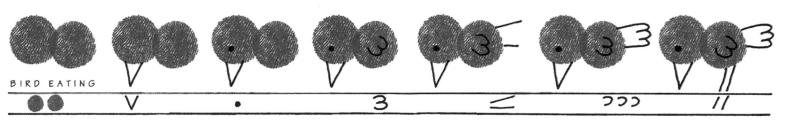

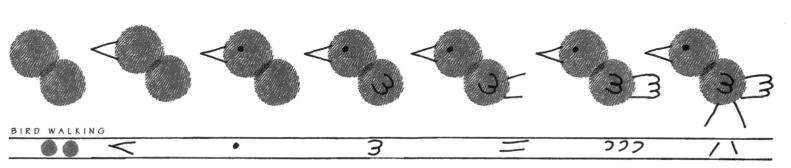

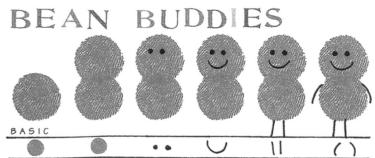

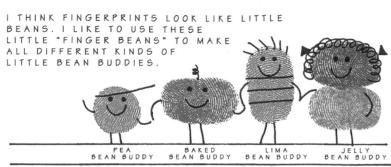

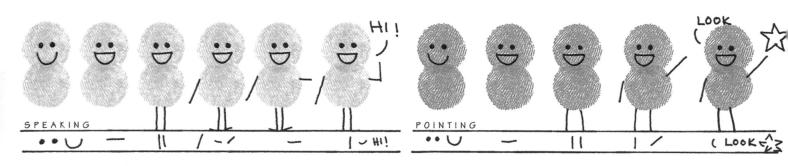

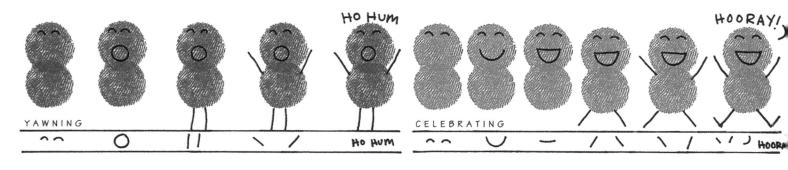

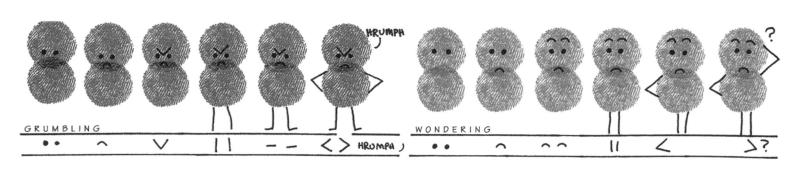

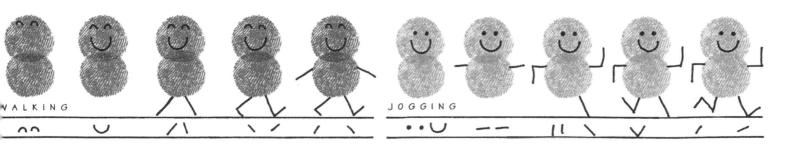

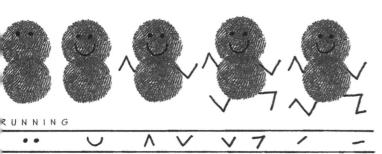

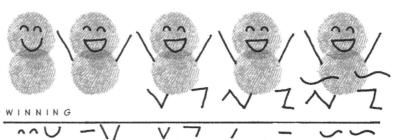

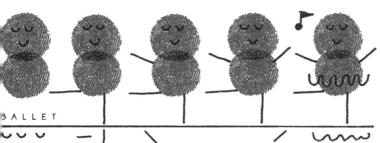

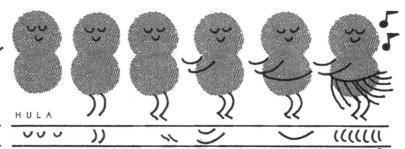

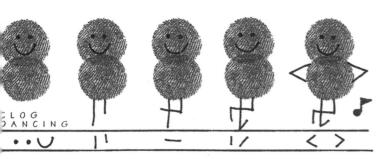

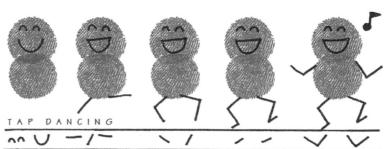

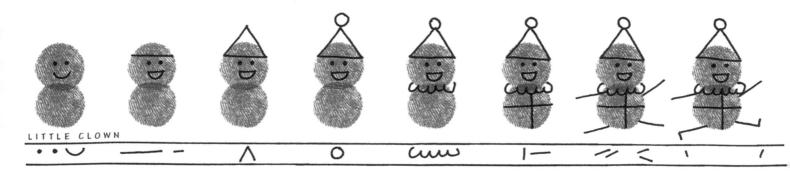

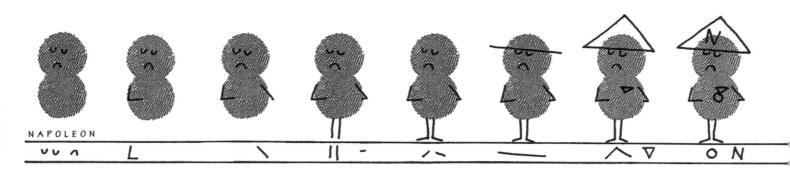

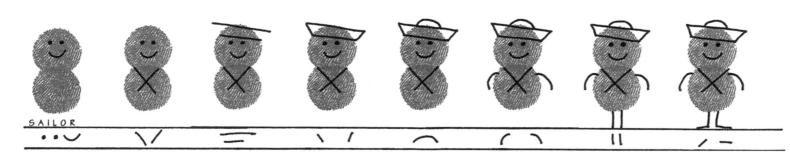

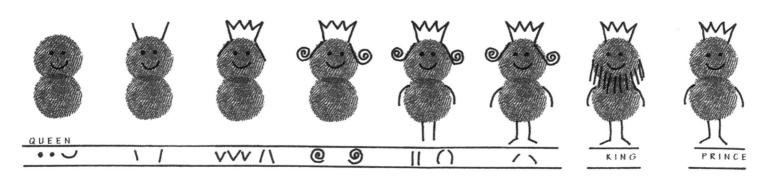

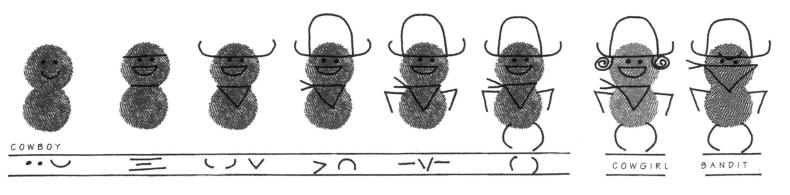

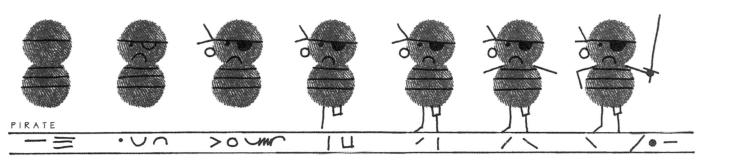

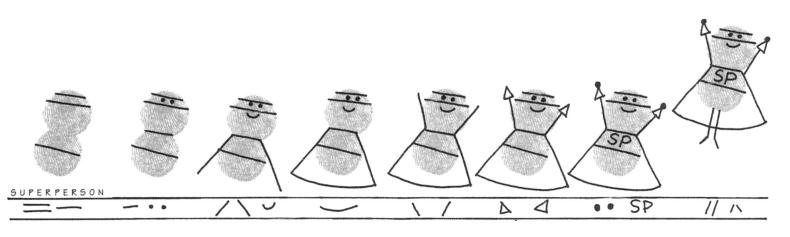

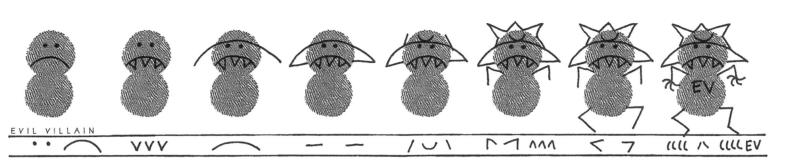

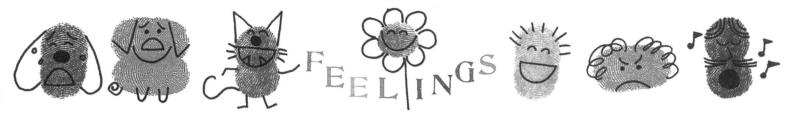

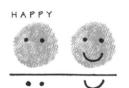

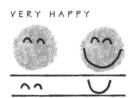

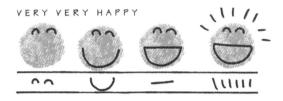

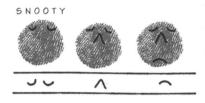

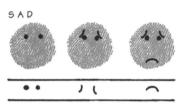

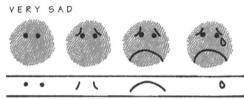

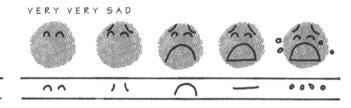

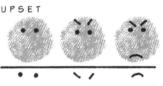

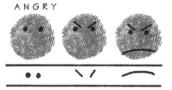

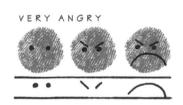

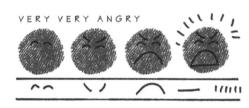

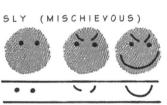

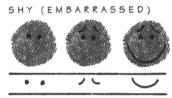

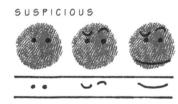

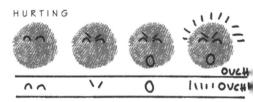

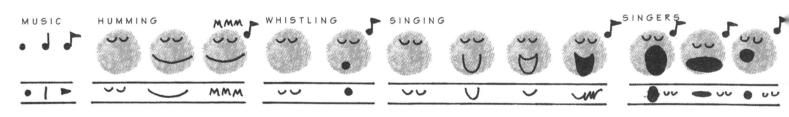

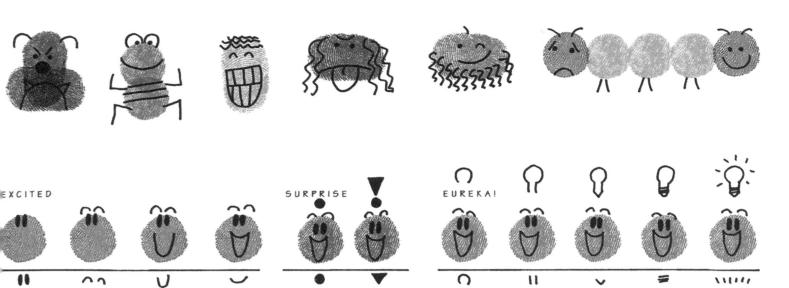

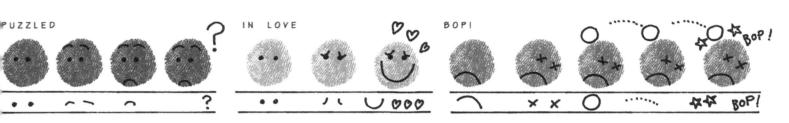

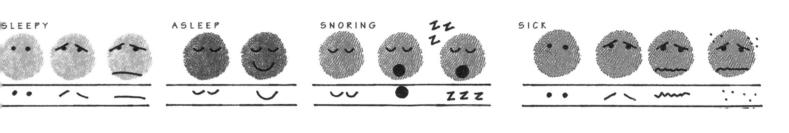

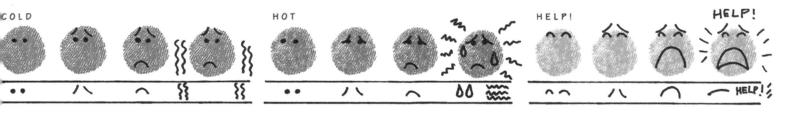

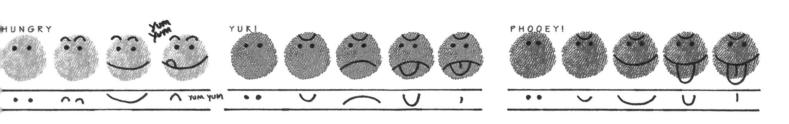

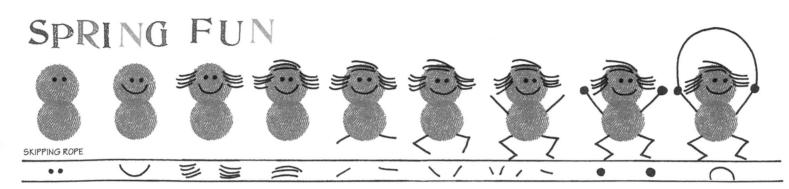

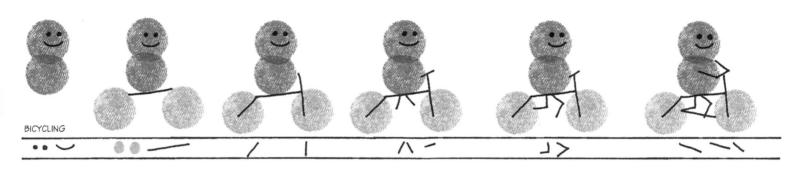

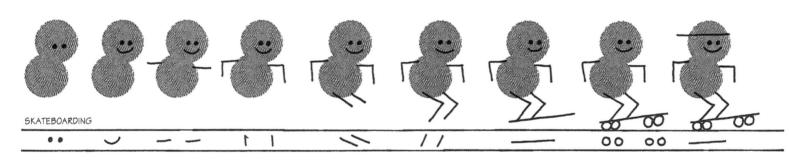

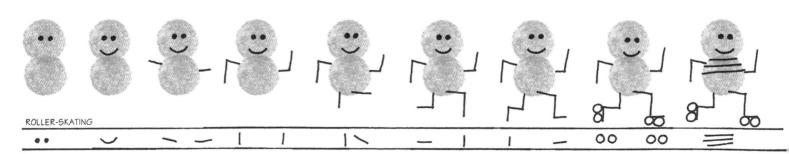

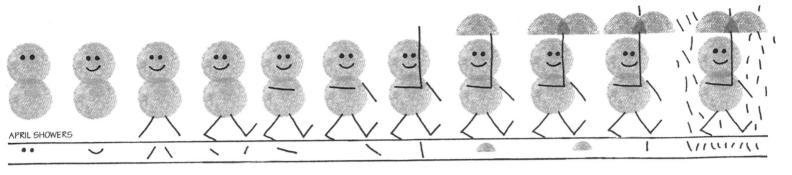

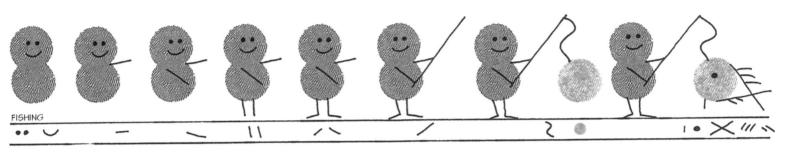

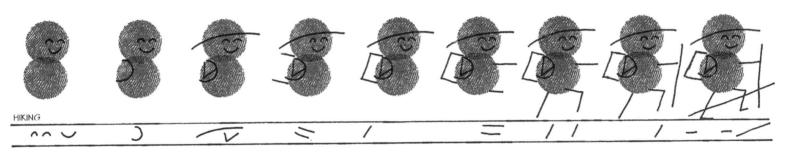

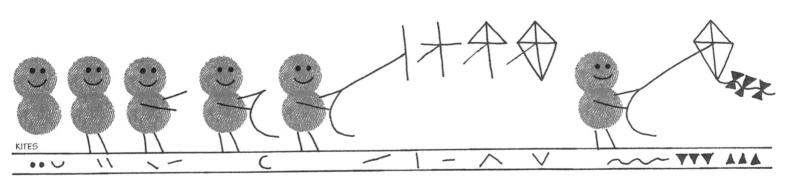

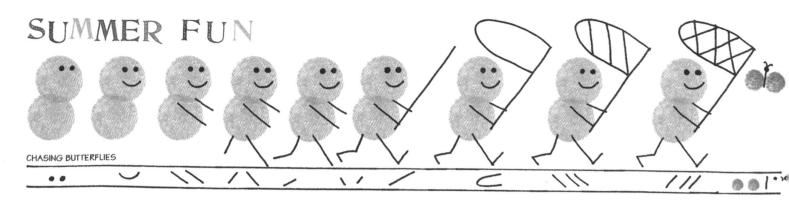

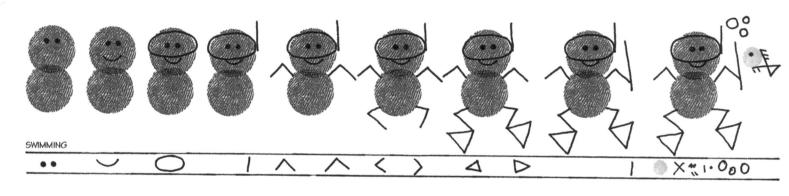

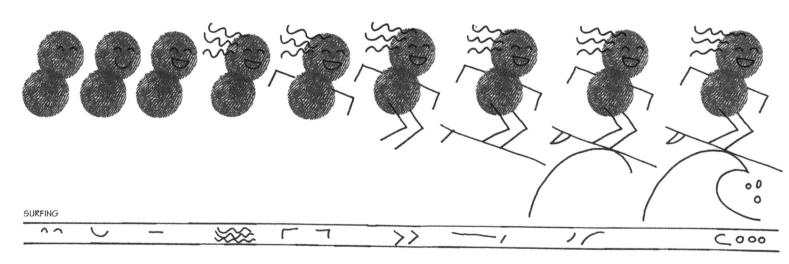

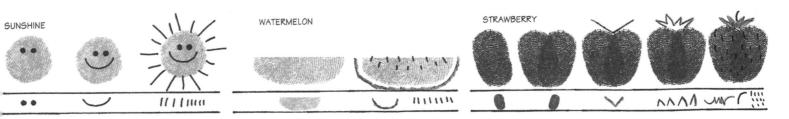

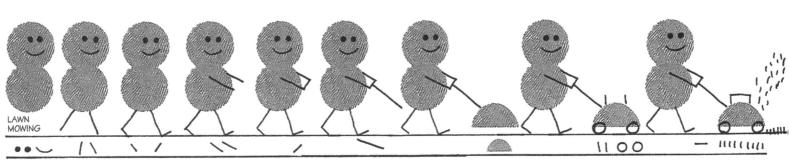

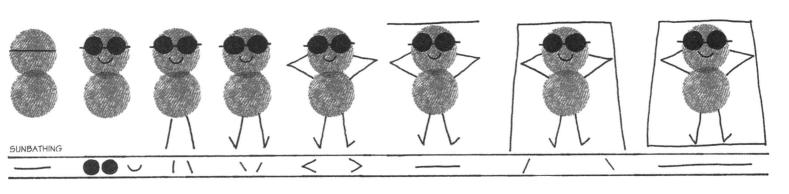

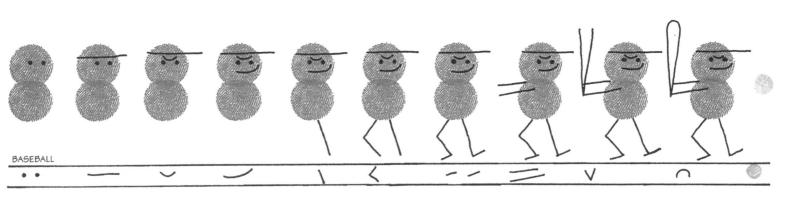

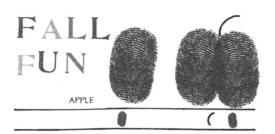

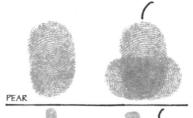

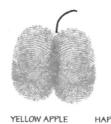

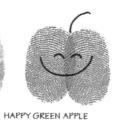

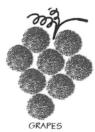

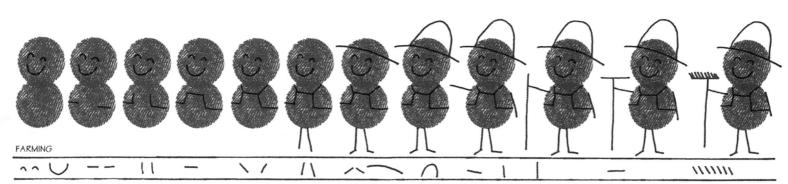

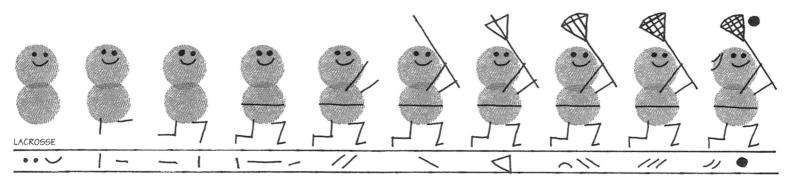

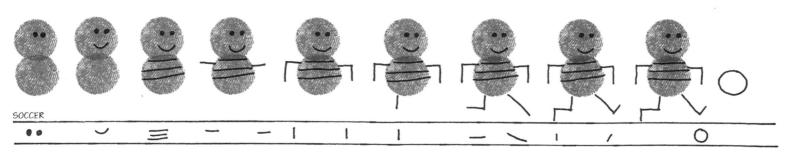

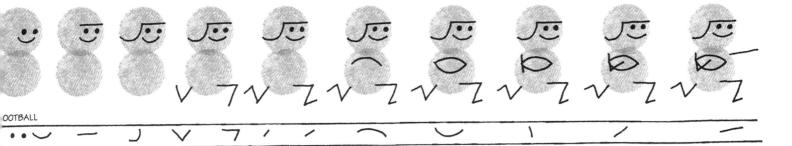

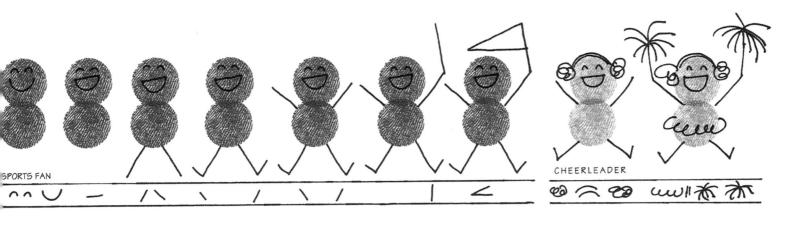

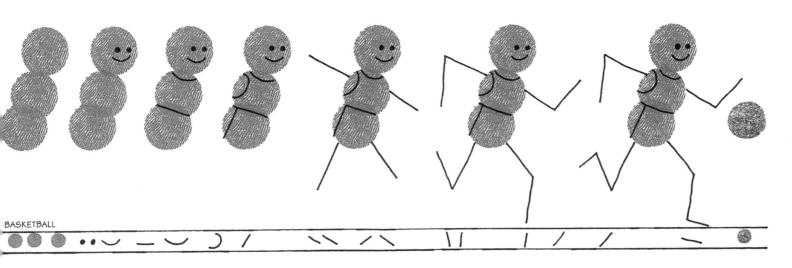

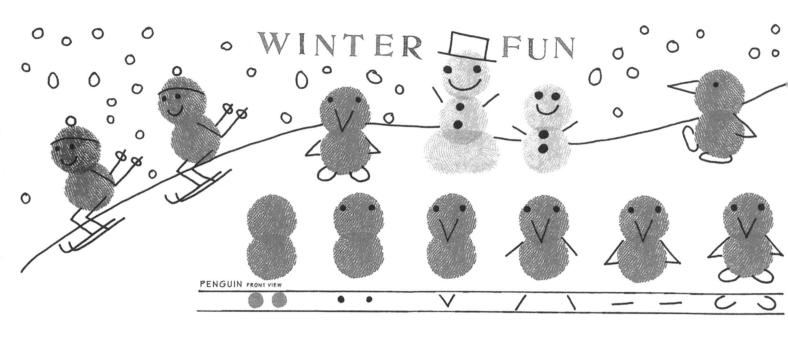

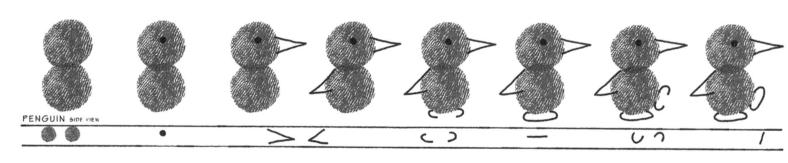

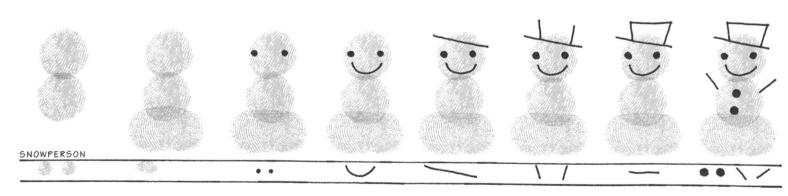

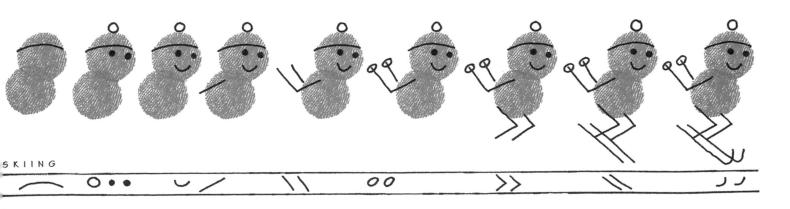

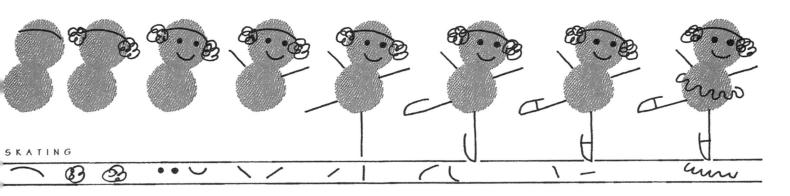

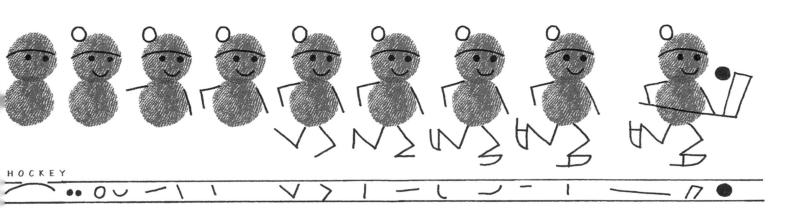

 \cup \cup

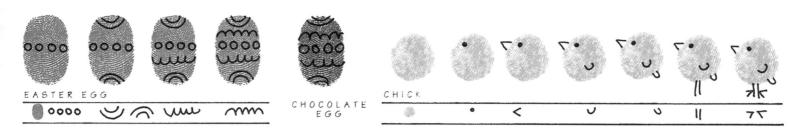

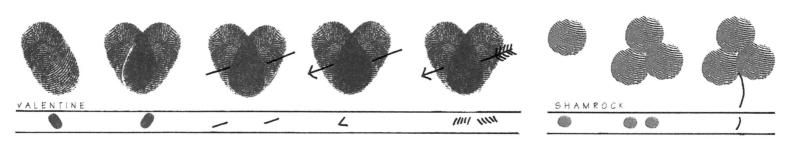

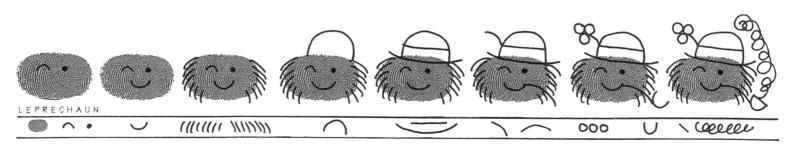

EASTER BUNNY

00

. .V

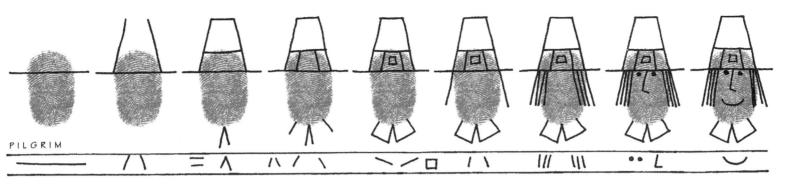

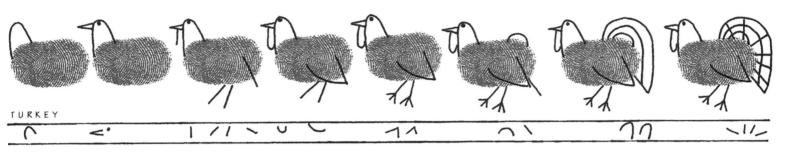

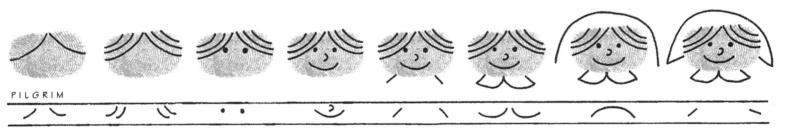

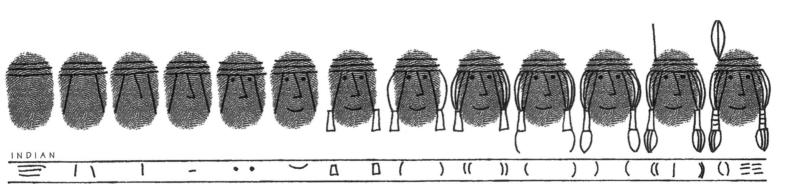

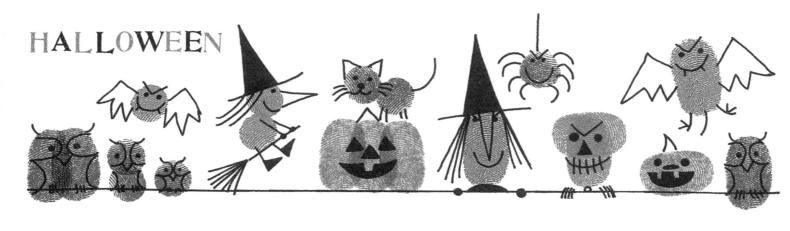

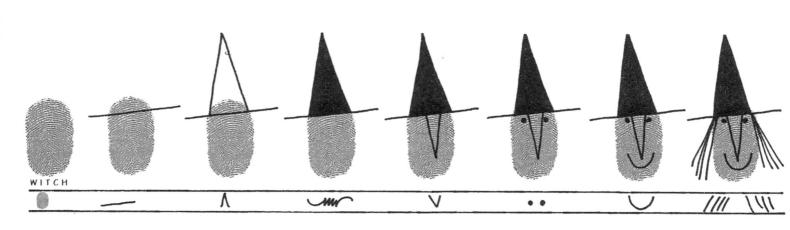

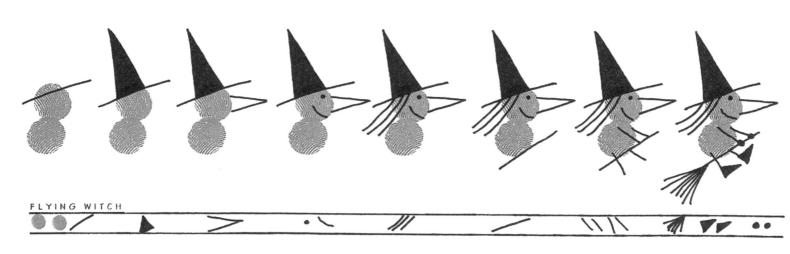

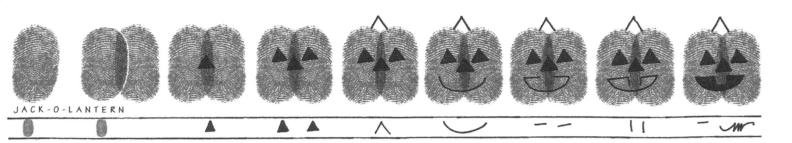

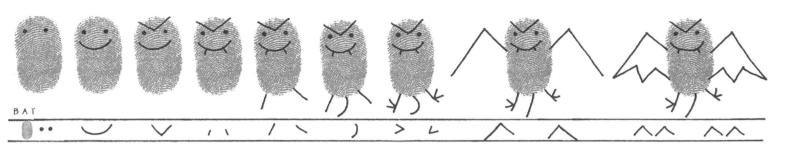

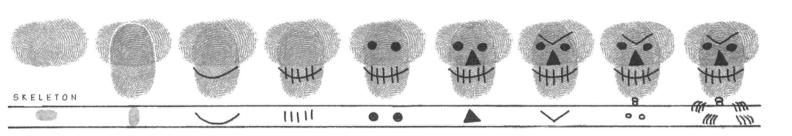

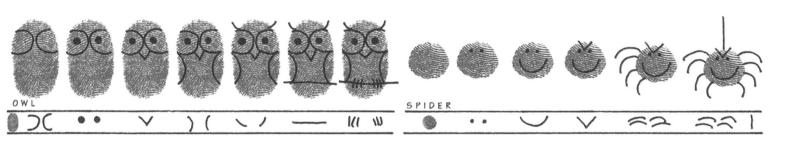

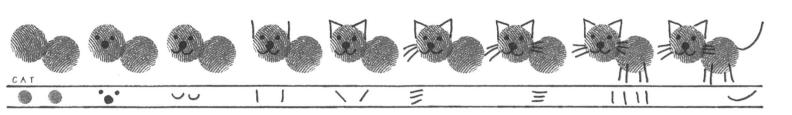

*DASHER * DANCER * PRANCER * VIXEN *

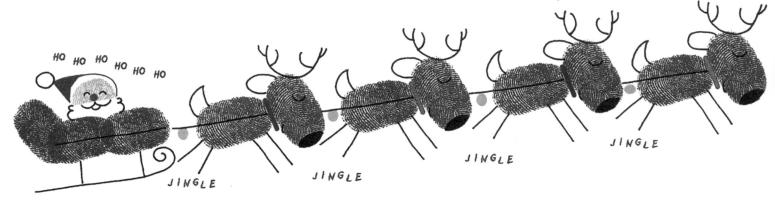

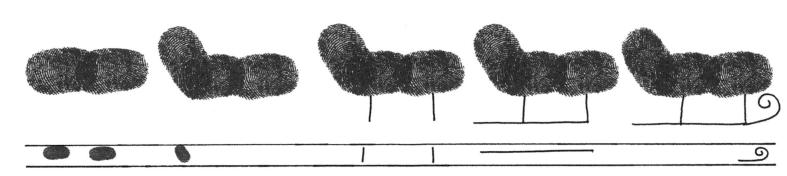

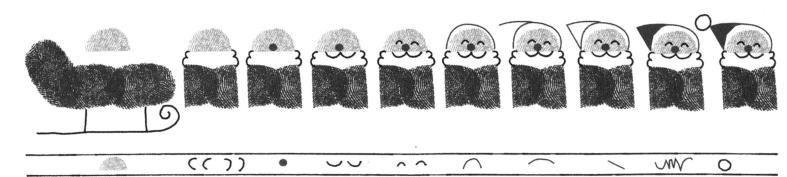

*COMET * CUPID * DONNER * BLITZEN*

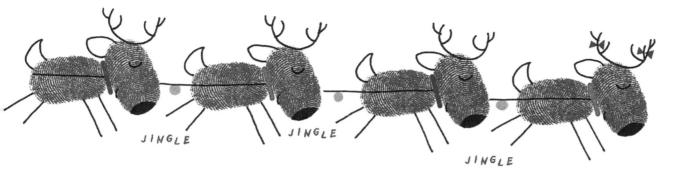

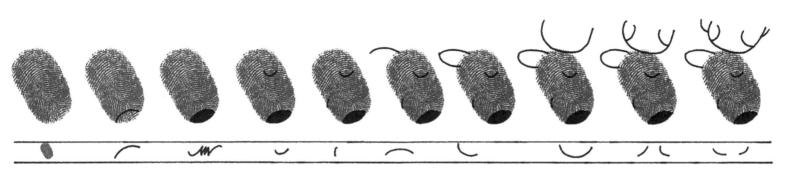

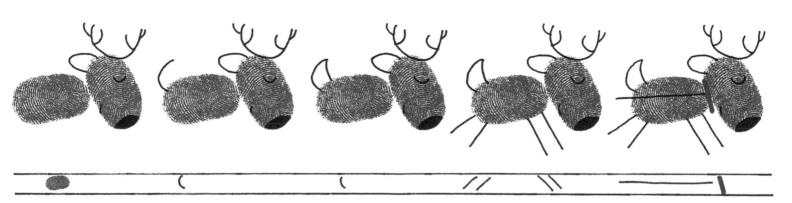

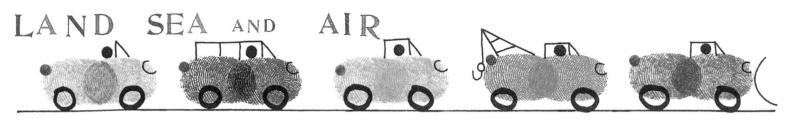

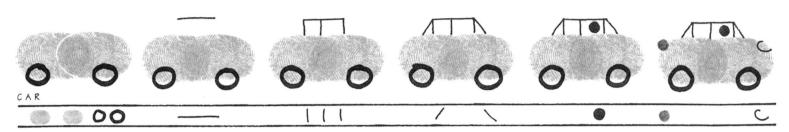

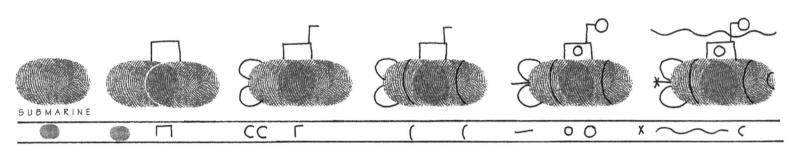

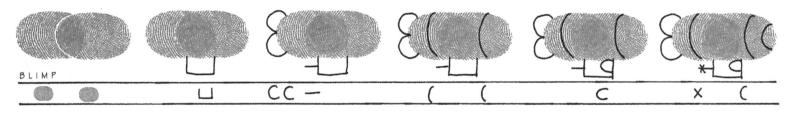

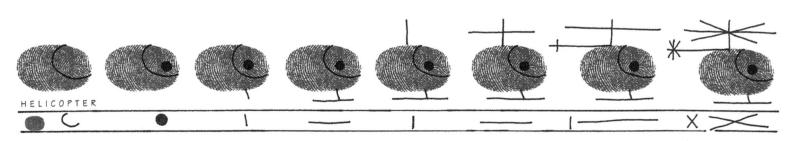

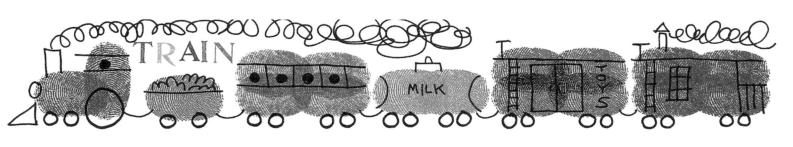

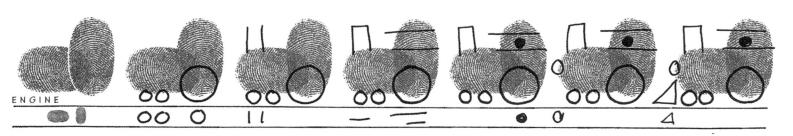

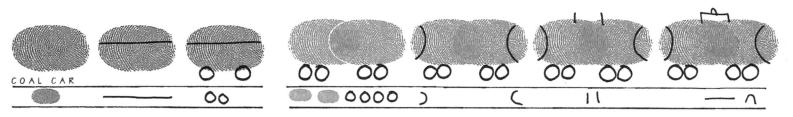

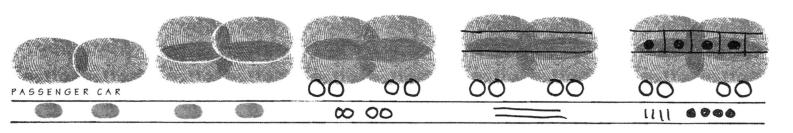

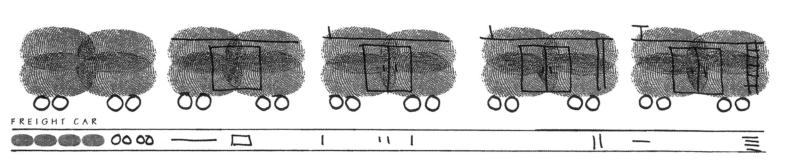

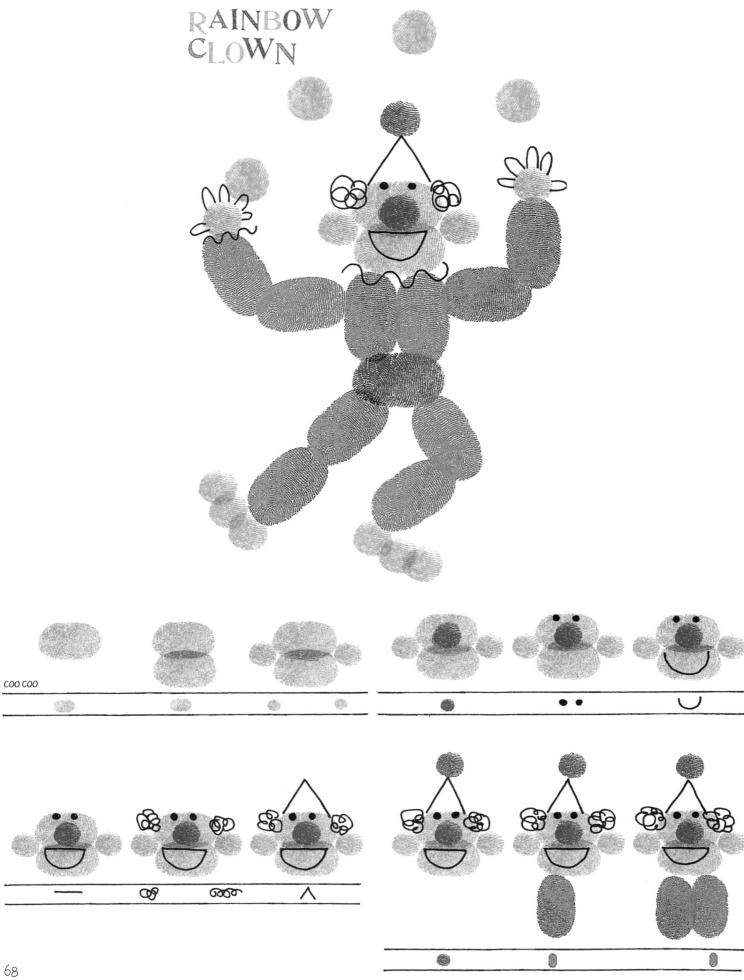

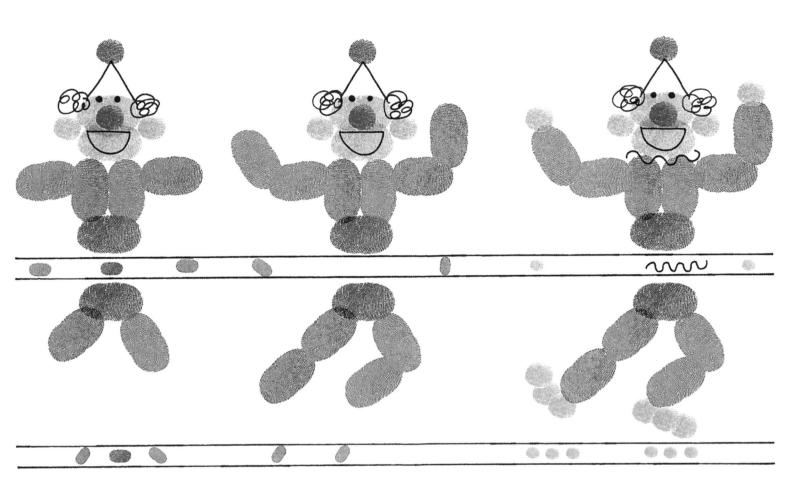

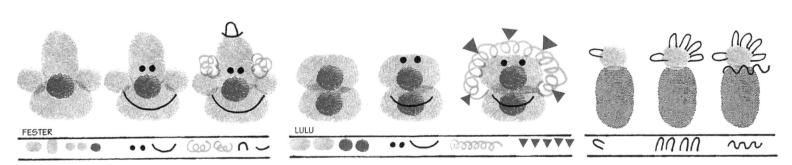

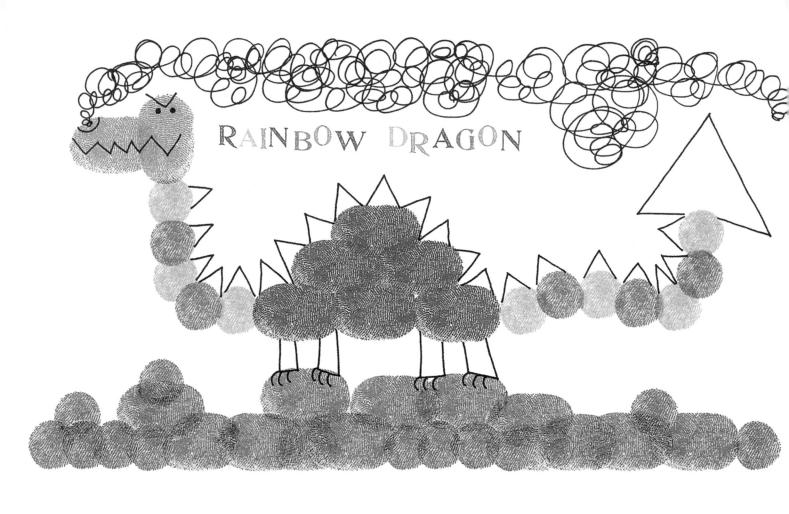

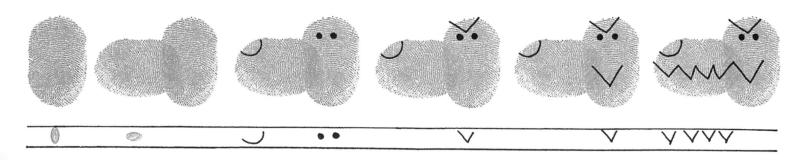

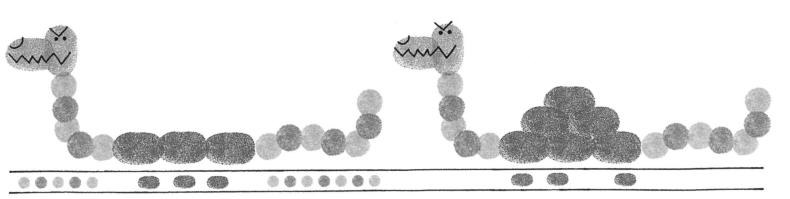

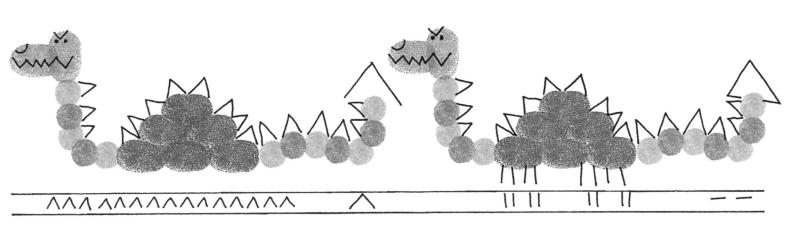

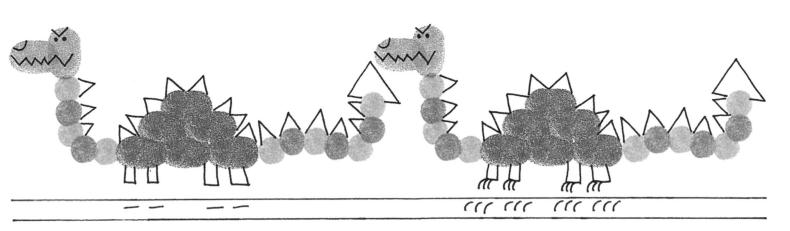

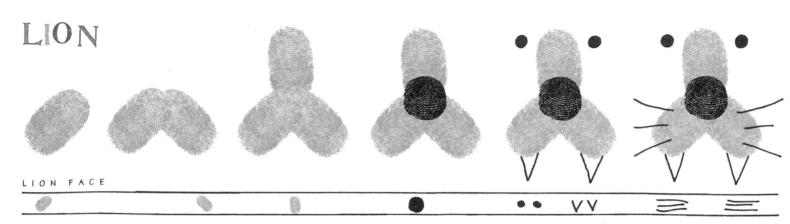

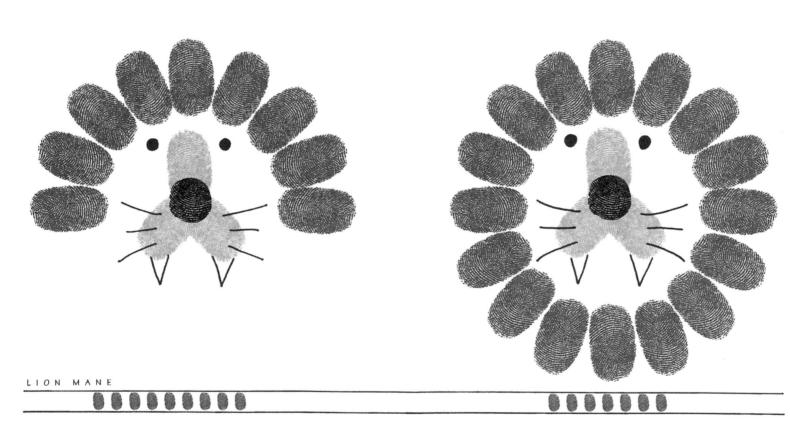

RAINBOW LIONS

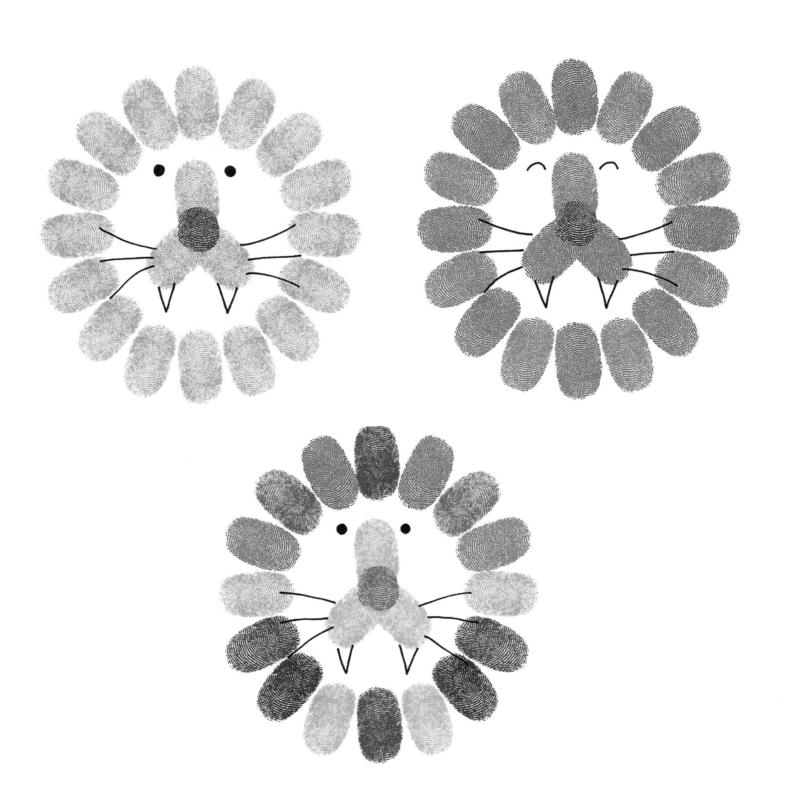

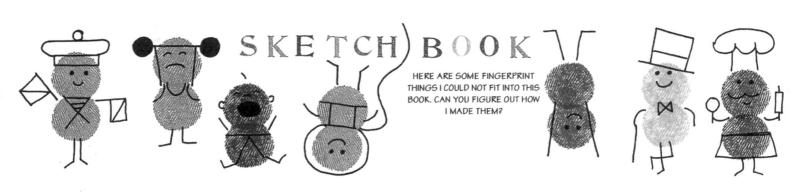

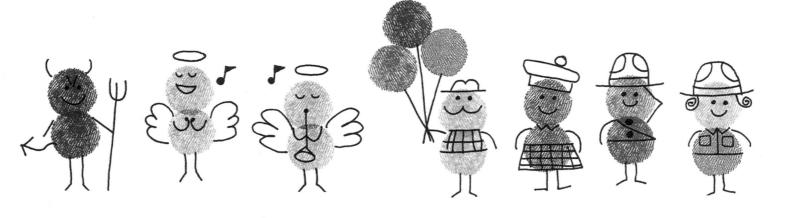

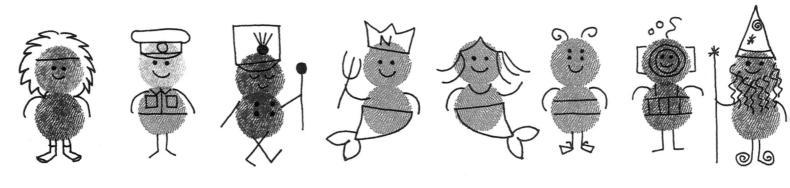

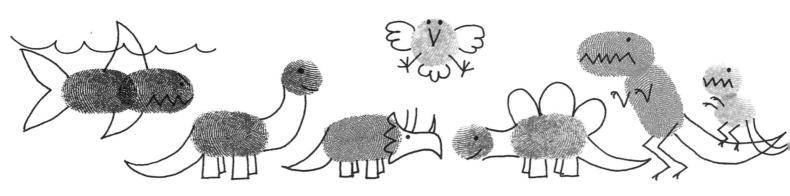

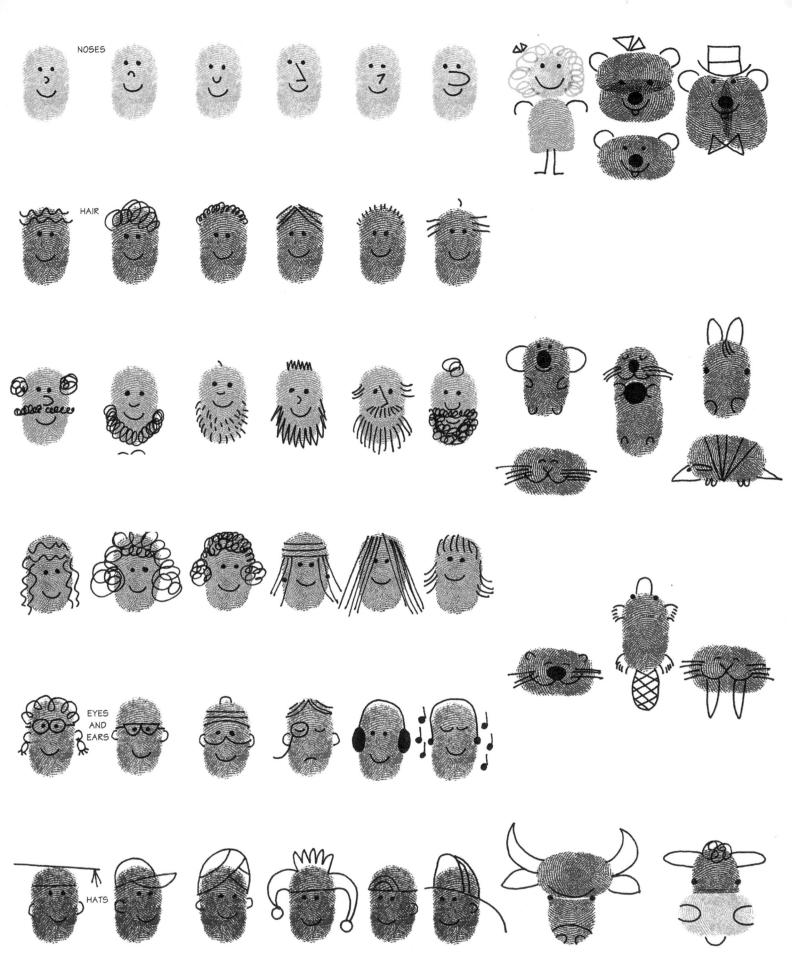

ADVANCED FINGER-PRINTING

FOR THE ADVENTUROUS—
JUST A FEW OTHER WAYS TO COMBINE PRINTS,
COLORS, SIMPLE LINES, AND SOME
IMAGINATION TO MAKE PICTURES.
THERE ARE LOTS LEFT FOR YOU TO DISCOVER.
HAPPY DISCOVERING!

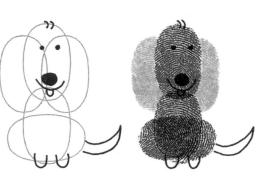

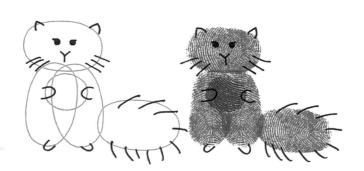

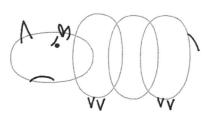

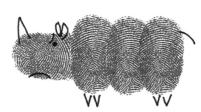

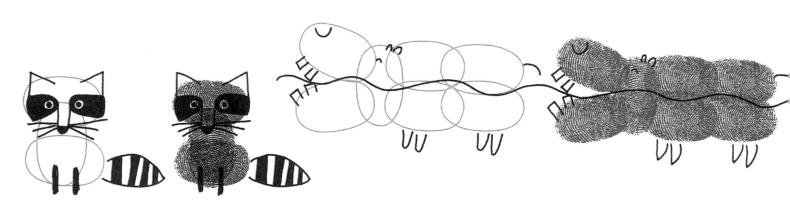

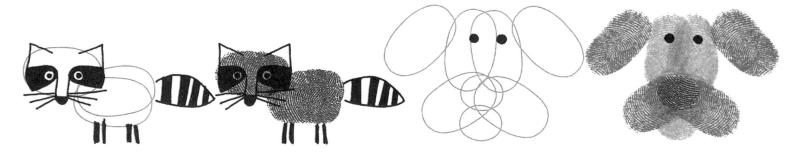

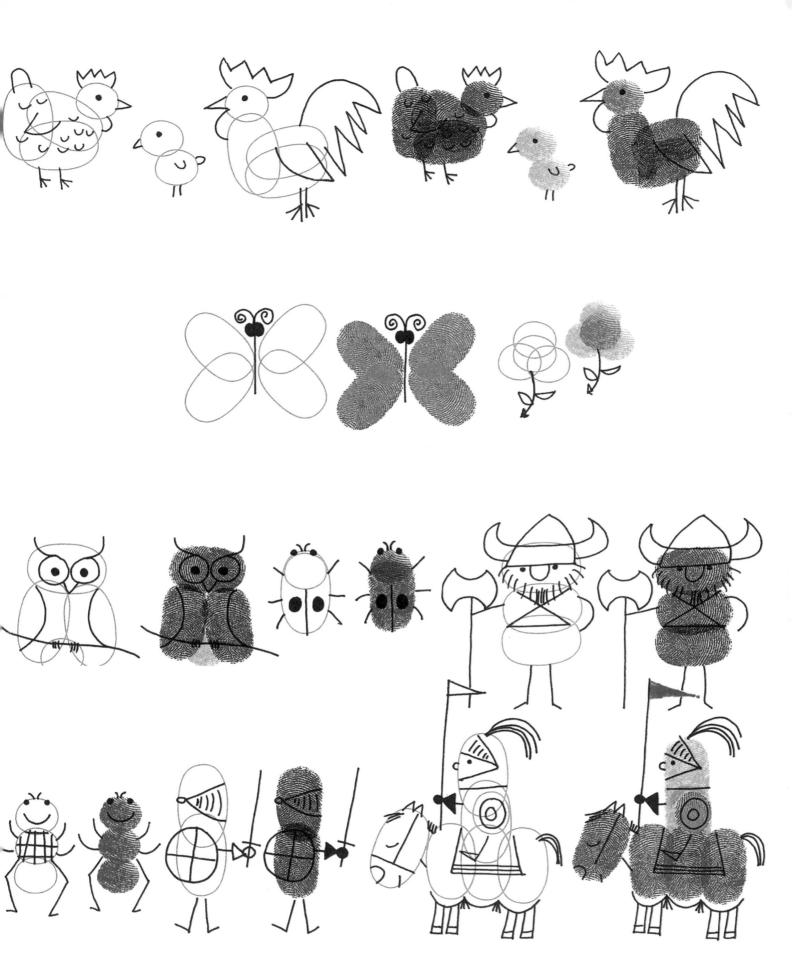

Something very special.

Just as no two fingerprints look just alike, no two fingerprint pictures will ever look just alike. Prints will be lighter or darker, lines will be thicker or thinner, colors will be different.

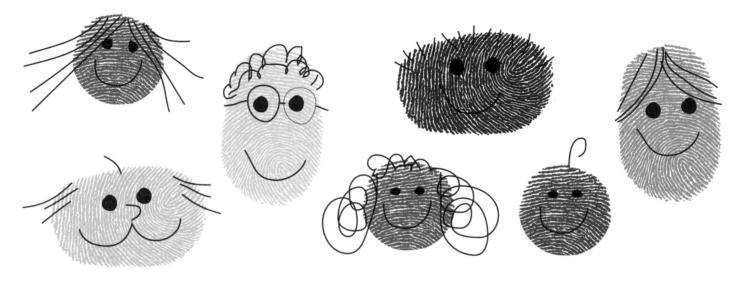

That means that no other fingerprint pictures will look just like the ones in this book, or just like yours. That's what will make your pictures "something very special."

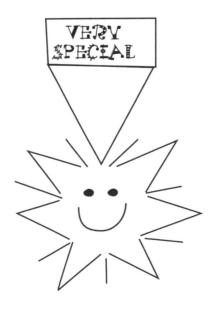

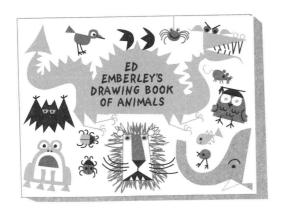

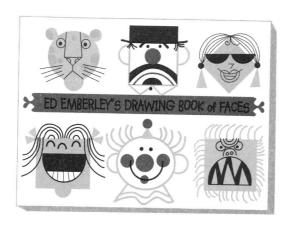

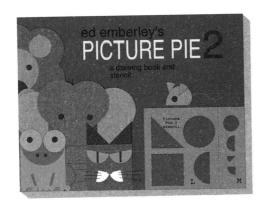

More Ed Emberley Drawing Book Fun!

ED EMBERLEY'S DRAWING BOOK
OF ANIMALS

ED EMBERLEY'S DRAWING BOOK
OF FACES

ED EMBERLEY'S PICTURE PIE, A CUT AND PASTE DRAWING BOOK

ED EMBERLEY'S PICTURE PIE TWO, A DRAWING BOOK AND STENCIL

THE WING ON A FLEA: A BOOK ABOUT SHAPES

ED EMBERLEY'S DRAWING BOOK,
MAKE A WORLD

ED EMBERLEY'S

BIG GREEN DRAWING BOOK

ED EMBERLEY'S

BIG ORANGE DRAWING BOOK

ED EMBERLEY'S

BIG PURPLE DRAWING BOOK

ED EMBERLEY'S BIG

RED DRAWING BOOK

DINOSAURS, A DRAWING BOOK BY MICHAEL EMBERLEY

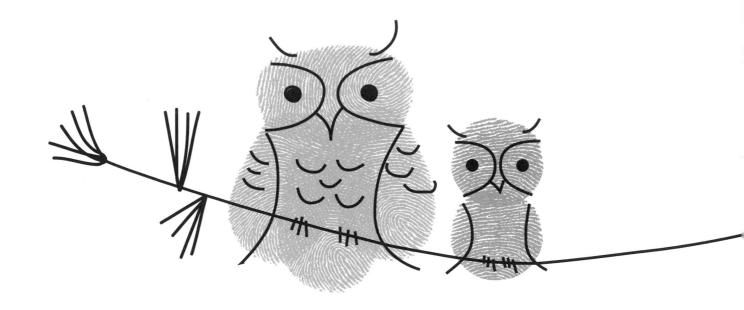

Copyright @ 2002 by Edward R. Emberley

All rights reserved.

No part of this book may be reproduced in any form or by any electronic or mechanical means, including information storage and retrieval systems, without permission in writing from the publisher, except by a reviewer who may quote brief passages in a review.

First Edition

From the previously published books by Ed Emberley GREAT THUMBPRINT DRAWING BOOK (copyright @ 1977) and THE FINGERPRINT DRAWING BOOK (copyright @ 2000)

ISBN 0-316-17448-3

10 9 8 7 6 5 4 3 2 1

WOR

Printed in the United States of America